ON LINE W9-CMJ-003

MONTVALE PUBLIC LIBRARY

DEMCO

Pastel
Workbook

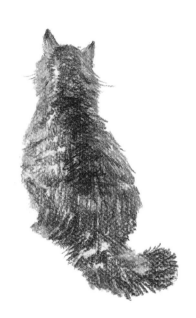

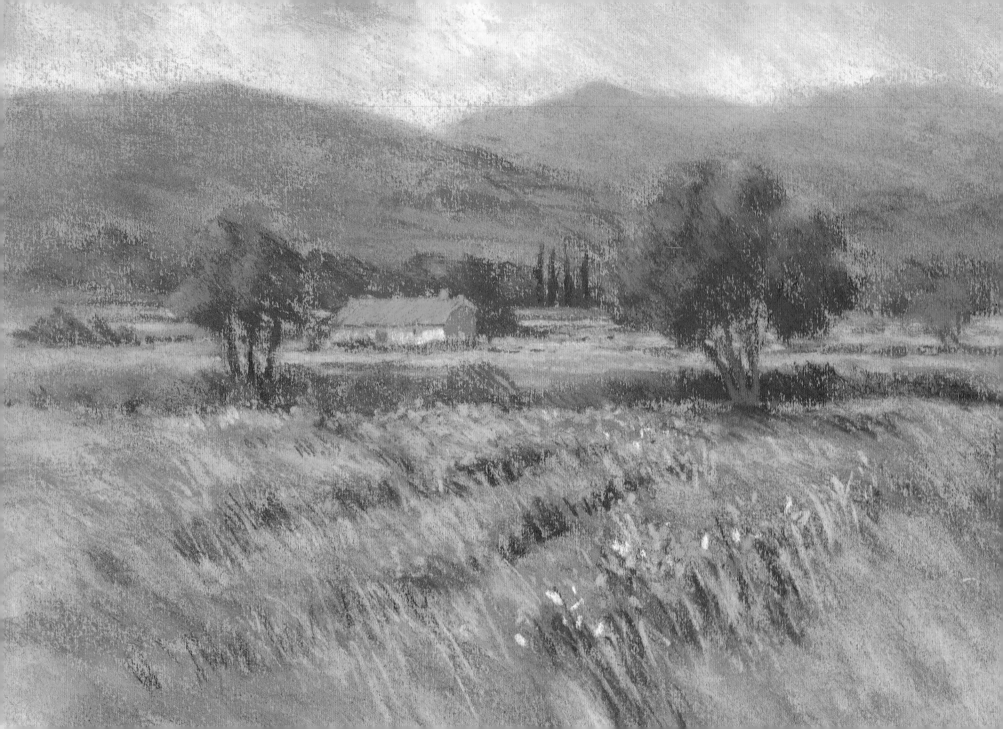

Pastel
Jackie Simmonds
Workbook

A COMPLETE COURSE IN TEN LESSONS

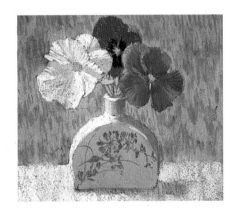

David & Charles

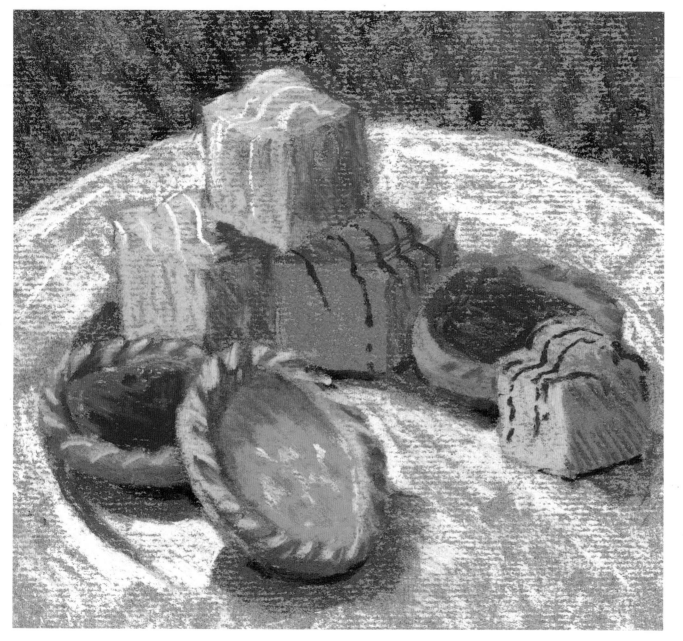

A DAVID & CHARLES BOOK

First published in the UK in 1999

A catalogue record for this book is available from the
British Library.

ISBN 0 7153 0843 2

Book design by Les Dominey Design Company, Exeter
and printed in Italy by New Interlitho

for David & Charles
Brunel House Newton Abbot Devon

Contents

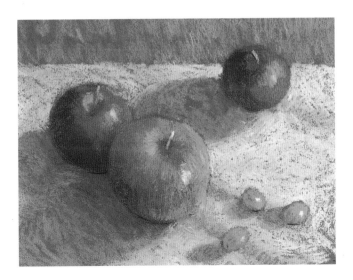

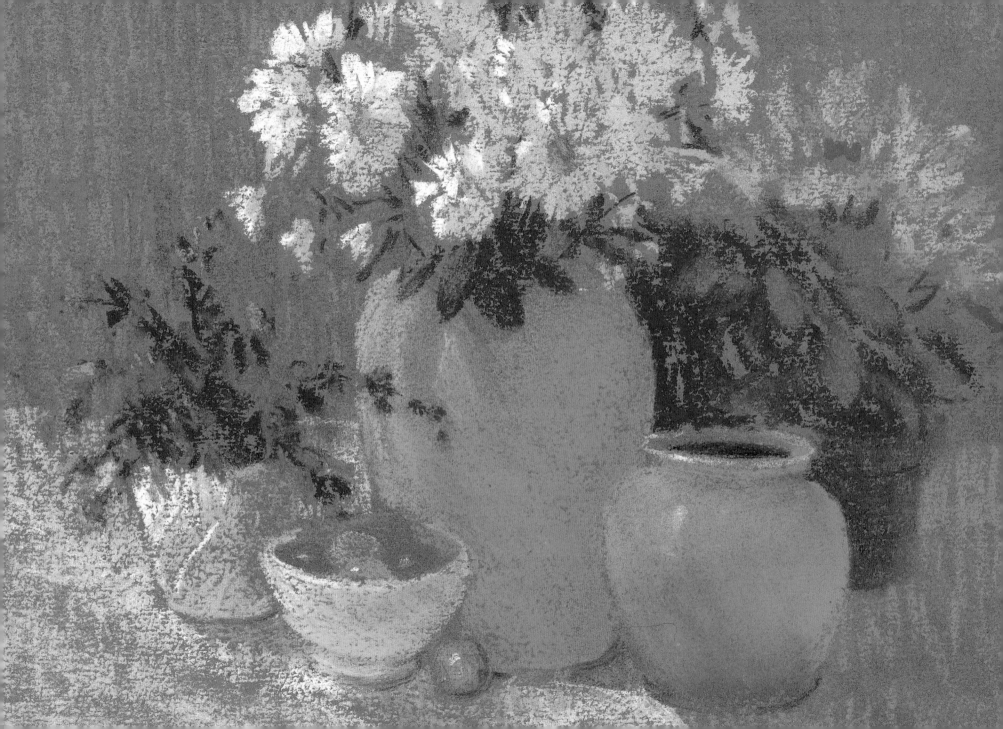

Introduction

Pastels are adaptable and exciting to use. If you have decided to try pastels after working with other mediums, I have no doubt that you will find their directness and ease of use refreshing and immensely liberating. If you are a complete beginner and have decided to begin with pastel – well done, you couldn't have chosen more wisely! You will find that pastels are delightfully straightforward to use, and with the minimum of effort you will soon be producing lively, colourful images.

Pastels are unique as a painting medium in that they are a dry medium, which means that they are applied directly to the paper without any mixing, water or turpentine. Perhaps the most appealing quality of pastels is their immediacy of effect, since the colour you pick up in your hand is the colour that appears on the paper, unlike watercolour which lightens as it dries, or oils, which can occasionally darken, or sink into the canvas giving a dull effect. Pastels give you fresh, pure, instant colour, which will help you to work with greater freedom and confidence. It is also fascinating to realise that a pastel picture is completely permanent. Its colours will not fade,

darken or crack, because pastels are, quite simply, sticks of pure pigment, held together with the minimum of binder. The pastel pictures of the great painters of the past are as fresh and colourful as the day they were painted.

Pastels have been used by artists for centuries, and in many different ways. In the seventeenth and eighteenth centuries they were used extensively for portraits, and in the nineteenth century many of the Impressionist painters used pastels for their work, revelling in the brilliance of the colours, and the ability to work quickly and directly with them.

I was encouraged to try pastels after looking at a painting by Edgar Degas in a major exhibition in London. I have to admit that, in my ignorance, I had imagined that pastels were mostly used for softly blended portraits, and I stood open-mouthed before one of Degas' pastel pictures. I was stunned by the way he had built up a shimmering surface of dazzling colour, the pastel layers scribbled and hatched over each other, so that previously applied colours could be seen glowing through subsequent layers, like so many tiny, brilliant jewels. The range and variety

of the colours in the image was breathtaking – from the palest, most delicate of pastel shades to rich, dark velvety tones. I could also see how versatile Degas found his pastels – not only did he paint by creating areas of colour and tone, he also introduced elements of drawing into his paintings, defining contours and edges with linear marks.

Perhaps it is this versatility of use that makes pastels so popular with today's painters. A visit to an exhibition of pastel paintings is certainly enlightening. You will find highly detailed works, where the pastel has been used so skilfully and carefully that you can see the soft fuzz on a peach and the sheen on a satin ballet shoe. You will also discover freer, looser, sketchy images where the pastel has been applied in a swift, spontaneous way to create an impression of the subject.

There is no best way to use pastels – no two painters will use them in quite the same way, and that is as it should be. Whatever medium you use, it should only be a means to an end – and the end should be an image which expresses your feelings about your subject, in the best way you can manage.

BLUE JARS AND
MARBLES

MAKING THE MOST OF THE WORKBOOK

This workbook is designed to familiarise you with pastels and to introduce you gradually to the main elements of picture-making. You will learn about the types of pastels available to you, and will discover how to find a range of marks with soft pastel by practising techniques and mark-making. After looking at materials and techniques, we will move on to the important basics of form, tone and colour. The lessons will then lead you gently step-by-step through some of the essentials of picture-making, helping you to develop your skills gradually. It is important to realise that learning to paint is a gradual process – and often, understanding what you read doesn't guarantee immediate success in practical terms! I ask my students to imagine a set of 'filters' existing between the brain and the hands: we take in information which gradually works its way down the arm, through the filters, until eventually it reaches the hands. Then the penny finally drops, and at long last we can begin to put to use the information we have absorbed!

An artist needs patience, because good progress depends upon lots of patient practice. You may produce failures from time to time – we all do, sometimes quite frequently. Then, it is necessary to persevere and work through each failure, without allowing yourself to be discouraged. You will succeed, and every success is a stepping stone to further improvement.

Learning painting techniques is fun and fairly simple, but clever techniques will not disguise poor drawing in a picture. You also need to develop the eye and hand muscles by sketching as often as you can. This will improve your powers of observation and your skills as a draughtsperson. Every spare moment spent sketching from life will pay huge dividends – it is encouraging to watch yourself improve, and also you will enjoy the wonderful bonus of discovering that you begin to 'see' differently – you will find yourself aware of colours, textures and shapes you had not noticed before, and the world becomes a lovelier place! Do sketch whenever you can; it will help you to make the most of the lessons in this book.

At the beginning of each lesson you will find a list of aims, designed to help you understand clearly what you are learning. Please re-read these aims regularly so that your experience and your understanding grow together. You will learn a lot if you copy the demonstrations in the book, but you will learn more if you set up something similar for yourself and paint from life, referring to the book for help and advice.

Be patient with yourself, and allow yourself to develop slowly but surely, savouring and enjoying the learning experience. Keep all your work – failures as well as successes. You will make progress, and you can judge your progress by studying earlier work. Soon, I promise, your ability will catch up with your ambition!

SUMMER CLOUDS

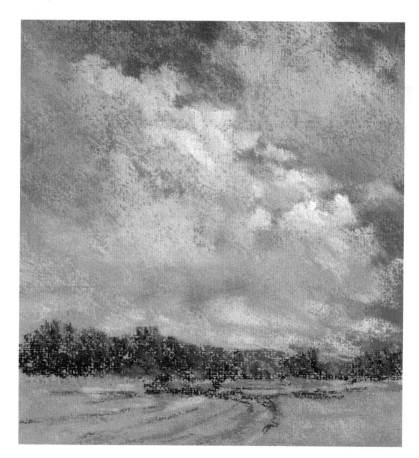

Materials and Equipment

One of the joys of working with pastels is the breathtaking variety of colour ranges to choose from – but this can also be rather mind-boggling! There are many brands on the market, and each manufacturer labels the colours in a different way. In fact, some boxes of pastels are sold without any labelling at all – you simply have to look for the colour you want to use. There are also different types of pastel – soft, hard, wax and oil, and each brand varies in texture. They also vary in size – you can purchase half-length sticks, full-length sticks, chunky pastels, thin pastels, and even great big jumbo sticks! There are all sorts of papers and boards to choose from, in rainbow colours. In fact, a visit to an art materials shop can be a very confusing business!

Initially, however, you really do not require a vast set of materials. A basic set of pastels, and a few pieces of paper or a pad of paper is enough to start with, and you can gradually build up a more substantial set of equipment in time, as your experience and enthusiasm increases.

All the different kinds of pastel can be bought in boxed sets, but they can also be purchased singly, so you can add to your collection slowly. If you buy a boxed set, you will find inevitably that you use some colours more than others – the greens and blues in a set may disappear quite quickly, whereas bright red or orange pastels might last for years! Being able to purchase pastels singly means you can replenish your set with ease.

An encouraging thought is that, unlike paint, which dries up in the tube if unused, pastels will never perish. If you put your pastels away for a while and return to them at a later date, they will be as good as new. In fact, if you find that you are not enjoying pastels as much as you had hoped, don't worry – put them away while you try other mediums and learn more about painting generally. I guarantee you will return to your pastels in due course.

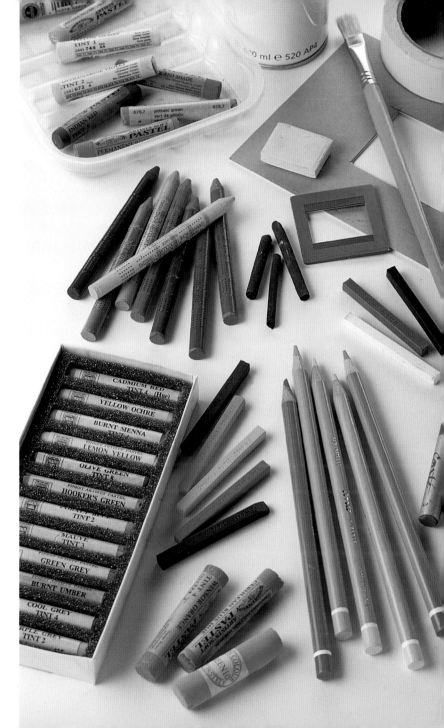

When starting to paint with pastels you will require only a small range of materials and equipment. Initially pastels and paper are all you will need.

PASTEL TYPES

I have used soft chalk pastels for most of the examples and demonstrations in this book. I have also used hard pastels and pastel pencils when they have offered a more suitable alternative. Oil and wax pastels require different handling, but do try a stick or two of each to find out whether you like working with them.

SOFT PASTELS

Sometimes called chalk pastels, soft pastels are pure paint pigment held together with a binder of gum with the addition of chalk or clay as a filler. They can be purchased in an enormous range of colours – some manufacturers have as many as 500 to choose from. Pastels vary in texture, quality and size from manufacturer to manufacturer, and you will soon discover which you prefer by buying one or two sticks from each range. They can all be used together, so you will not waste your money!

HARD PASTELS

Hard pastels are made with less pigment and more binder than soft pastels, and can be bought as sticks or pencils. Hard pastels are useful for linear work (partly because they can be sharpened), and pastel pencils are particularly useful as a sketching tool. Conté sticks and pencils are available in a wide range of colours including the traditional black, white, sepia, bistre and sanguine (which is much like the red chalk that was used in drawings by the great master artists).

OIL PASTELS

Oil pastels are very different from soft or hard pastels, both in consistency and use. They are obtainable in far fewer colours, and they vary in texture – some are soft and rather sticky; others are firm and dense. Marks can be softened and spread with turpentine, and although they are not strictly compatible with soft pastels, some professional painters do combine them in mixed media paintings.

WAX PASTELS

Wax pastels are similar in texture to oil pastels, but they are less moist. Some manufacturers produce a wax pastel that is watersoluble, which allows marks to be dissolved with water to create interesting blended effects.

From left to right Soft pastels, hard pastels and pastel pencils, oil pastels, wax pastels.

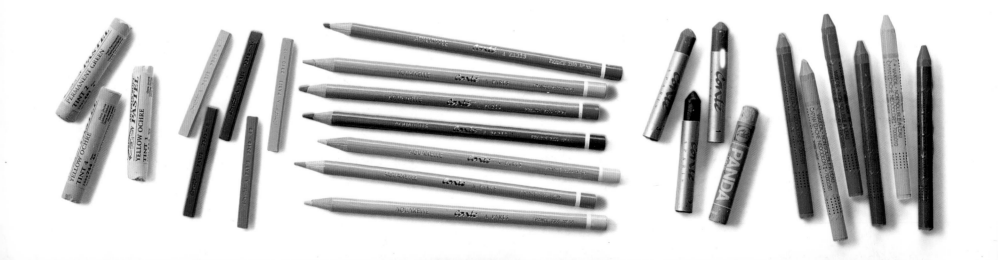

A BASIC PALETTE

I usually recommend a boxed set of 36 pastels as a starter kit for beginners. However, many people find that the colours in boxed sets aren't always to their liking and prefer to select their own range. Some shops will allow you to choose colours from their range of loose sticks, and swap them for some of the colours in the box – it is certainly worth asking the question! As a general rule, it is useful to have a good selection of dark, medium and light tones of as many of the main colour groups – blues, greens, reds, yellows and greys – as you can afford.

You will find that most manufacturers number their pastels as well as name them. The lighter tones usually have a low number, and the darker tones a high one, but don't worry too much about names and numbers – you will soon become quite used to selecting by eye.

If you like the idea of choosing your own colours, use my suggestion for a basic 'palette' as a guide to a range for your own selection. The names simply relate to the pigment colour and are only a rough guide. I have defined the colours by light, medium and dark tones with the letters L, M and D. Palettes for individual paintings are shown for all the projects in the book.

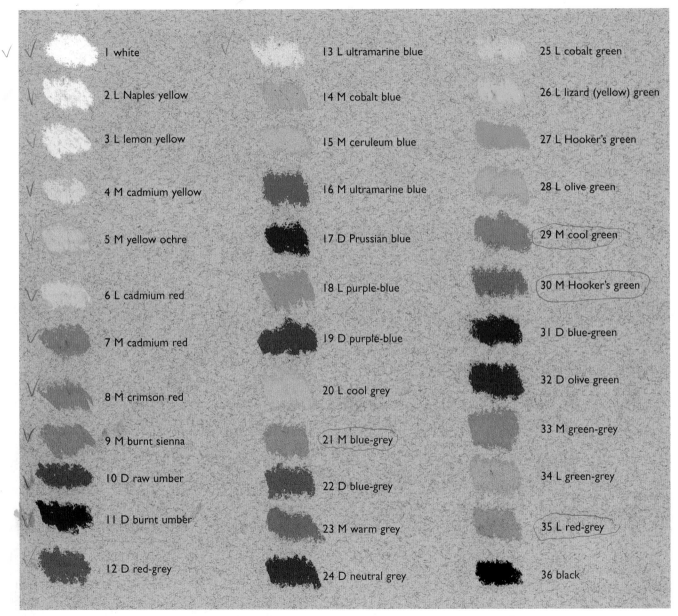

1 white
2 L Naples yellow
3 L lemon yellow
4 M cadmium yellow
5 M yellow ochre
6 L cadmium red
7 M cadmium red
8 M crimson red
9 M burnt sienna
10 D raw umber
11 D burnt umber
12 D red-grey

13 L ultramarine blue
14 M cobalt blue
15 M ceruleum blue
16 M ultramarine blue
17 D Prussian blue
18 L purple-blue
19 D purple-blue
20 L cool grey
21 M blue-grey
22 D blue-grey
23 M warm grey
24 D neutral grey

25 L cobalt green
26 L lizard (yellow) green
27 L Hooker's green
28 L olive green
29 M cool green
30 M Hooker's green
31 D blue-green
32 D olive green
33 M green-grey
34 L green-grey
35 L red-grey
36 black

SUPPORTS AND SURFACES

Pastels can be applied to almost any surface that has a certain amount of texture for the pastel to grip onto (try applying pastel to a shiny surface, and it will simply slide off!). You can use pastels on cardboard, wrapping paper, canvas, sugar paper, pastel paper, pastel board, and even on sandpaper (the very fine sandpaper which is available from art shops).

Pastel paper is the most popular surface, and the best to start with. These papers vary slightly from manufacturer to manufacturer. Some will have a pronounced texture on one side and a smooth surface on the other – you can choose which you prefer to work on as there is no 'right' or 'wrong' side to use. Some papers have laid lines (created in the manufacturing of the paper) which will show through thin layers of pastel.

Pastel board is created by blasting cork fibres onto card, to provide a slightly gritty surface. Working on pastel board or sandpaper uses up lots of pastel, and is, in my opinion, rather more difficult for a beginner than working on paper, but once you are used to working on paper, do try these different surfaces – you might love them. We will look at these in Lesson Ten.

All pastel papers, and the more expensive pastel boards, are available in a variety of colours. We will see how the colour of the paper can affect your work in Lesson Two.

From left to right Two pastel boards, silver-grey sandpaper, 'not' surface watercolour paper, and assorted sheets of pastel papers.

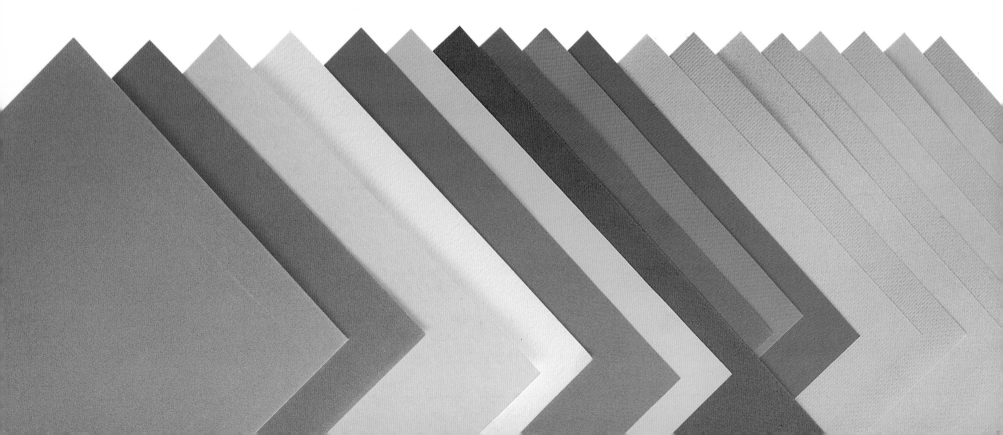

ADDITIONAL EQUIPMENT

Although you really don't need much more than a box of pastels and some paper to make a start with pastel painting, there are some extra bits of equipment that you will definitely find useful. When you study the list on this page you will see that this does not involve a great deal of extra expense.

Charcoal

This traditional drawing material, made of charred twigs of vine or willow, can be bought as sticks or in pencil form. I use this for drawing in the early stages of a painting, since it dusts off leaving a faint trace of the original lines which can be worked over easily with pastel. A box of charcoal sticks will last for a long time. (It is better to avoid graphite pencil for initial drawings as it produces shiny marks which sometimes resist pastel.)

Tissues

You will find tissues useful for dusting off charcoal and for blending pastel. A cheaper alternative is soft toilet tissue, but kitchen roll will not do the same job!

Old hogshair paintbrush

A stiff bristle brush, traditionally used for oil painting, can be very handy for brushing off unwanted areas of pastel from the surface of the paper. An old brush will do, since it is only being used to make corrections.

Putty rubber

This can be moulded to a point for removing small areas of pastel, and is useful for correcting preliminary drawings in charcoal.

Torchon

These are stiff, rolled tubes of paper. Some artists use these for blending in small areas, where a finger will be too clumsy. Cotton buds are a cheap alternative, but they lose their point very quickly.

Small hand mirror

If you turn your back to your work and view it in the mirror, areas which need adjustment suddenly seem more obvious. It is like having a fresh pair of eyes – you will be surprised at how useful a mirror can be.

Craft knife

Essential for sharpening pastel pencils, and useful for cutting paper.

Sketchbooks

Essential for practice, thumbnail sketches, and more! There are many types available; I suggest that you have at least one sketchbook of white cartridge for drawing, and one of pastel paper.

Fixative

I recommend that you use low-odour, CFC-free aerosol fixative. Fixative secures the pastel particles to the surface to a certain extent. I will explain its use more fully on page 27.

Handwipes or a damp cloth

Use these to clean grubby fingers – pastels are not for the fastidious!

Plastic vegetable tray

The packaging that comes 'free' with vegetables at the supermarket is very useful as a hand-held palette, far better than clutching a handful of pastels and getting cramp in your hand!

Graphite pencils

Have several pencils in various grades of softness for sketching.

Conté sticks or pencils

Black, white and sanguine are useful for sketches.

Drawing board

Making your own is far cheaper than buying a board in an art shop. A thin plywood board is fairly lightweight, and firm enough – simply rub some sandpaper over the edges to prevent splinters. Make sure you buy a piece of wood big enough to take a full-size sheet of pastel paper – approximately 76 x 60cm (30 x 24in).

Masking tape or bulldog clips

You will need tape or clips to attach your paper to the board.

Easel

I recommend working at an easel but it is not essential.

Tip

When you reach Lesson Ten you will require some extra materials and equipment if you want to create your own surfaces to work on.

OUTDOOR EQUIPMENT

Working out of doors requires a little thought and organisation, since you need your kit to be portable and as lightweight as possible. There is nothing more frustrating than discovering you have forgotten something vital when you go out to paint. It's a good idea to make yourself a check list of all the items you like to carry. Keep it in your rucksack and before each expedition double-check that you have everything you need. My own check list is shown on this page. (Except for the drawing board, my kit fits into a large rucksack.) You may prefer to adjust this list to suit yourself – no two people work in quite the same way, after all.

Outdoor Equipment Check List

Lightweight drawing board I use foamboard (a shiny white board filled with polystyrene). Although it can be dented, it compensates by being fairly inexpensive and almost weightless!

Sketching easel Use a lightweight collapsible aluminium easel. On windy days an easel can be anchored with something heavy suspended from the hook on its paper support. If it is very windy, it is probably best not to work at an easel because the board will be buffeted around. The best option is to work on your knees or lap, perhaps using the easel partly erected as a support for the board.

Sketching stool A folding, lightweight stool with a backrest is ideal. A plastic blow-up cushion is an alternative, but only if your back is very strong indeed!

Camera Useful for back-up reference.

Tissues and moist handwipes

Plastic vegetable tray

Fixative Alternatively, for sketches and practice paintings use a small can of hairspray (but not for your fully worked paintings).

Sketchbook and graphite pencil

Set of pastels

Pastel pencils or coloured pencils Totally optional: I find them useful for quick colour notes.

Plastic bag and bulldog clips Take a bag big enough to cover the drawing board. At the end of the day, cover your picture with the bag and secure with bulldog clips, and then you won't accidentally wipe your picture off on your clothes.

STORING PASTELS

The problem of storing pastels, particularly if you buy them individually (rather than in boxed sets), is one of great concern to every student I have met – and quite rightly so, because soft pastels rattling around loose in a big box will rub against each other, and before long they will all appear to have turned grey. It is best to store different groups of colours separately, either in different boxes, or in a box or tray with a number of compartments.

HOMEMADE CONTAINERS

DIY enthusiasts will enjoy making containers and trays for storing pastels: cigar boxes or large trays can be divided with balsa wood partitions to make compartments for separate colours. I'm no carpenter, but I found it quite easy to make an inexpensive pastels tray for myself by fitting a piece of hardboard to a large picture frame as a base. Then I made simple partitions out of balsa wood, and lined each partition with thin sheets of foam rubber.

READY-MADE BOXES

Boxed sets can often be purchased ready-lined with foam cut into slots, or little wells, one for each pastel – ideal for

someone with a tidy mind who likes to keep their pastels separate and as clean as possible, rather than have them all rattling around together. You can buy beautiful wooden boxes made especially for pastels, which have carrying handles and removable lids – look in the classified sections of art magazines for these. It is even possible to buy an easel with a pastels storage box which can be carried separately and then hooked onto the easel – a luxury item, perhaps only to be invested in if you are really serious!

ECONOMY STORAGE

At the other end of the scale, you can use snap-top plastic containers, fishing tackle or art boxes, or even inexpensive plastic tool boxes (the kind you buy to store screws and nails). A simple, cheap idea for a tray with compartments is a plastic cutlery tray. Line the boxes or trays with foam rubber to cushion the pastels.

CLEANING PASTELS

Clean pastels by dropping them into a tray or plastic bag full of semolina or ground rice. Give them a good shake, then pour the whole lot into a sieve, over a bowl. You will then have filthy semolina, and sparkling clean pastels!

ORGANISING YOUR WORKING AREA

When working indoors, it is best to attach your paper to a firm wooden drawing board with masking tape or bulldog clips. Most people use wooden drawing boards. Although you can work at a table, you really need to have your board at an angle that will allow the pastel dust and crumbs to fall away. (Resting a board on your knees is likely to result in a lap full of pastel debris.) You need to keep your arms and sleeves clear of the picture too, otherwise you are likely to wipe your sleeves all over your work.

I recommend you try an easel. A tabletop easel is not very practical unless you can anchor it to the table in some way, or it will push back as you work. A standing easel is best. If you find it difficult to stand for any length of time, simply use a tall stool, as I do. If your floor is carpeted, make sure you protect the carpet with a dustsheet of some kind.

I know it isn't always easy, but I recommend that you try to find a corner of a room to set up a little studio for yourself, rather than work on the kitchen table from time to time. You will be much less inclined to get started if you have to set up and put away all your equipment every time you want to produce a picture. If your working area is set up and ready to go, you will find yourself drawn to it like a magnet – even if it is only for a few minutes at a time. And regular practice is the only way to make real progress.

Try to organise your corner or room with a working surface, shelves for reference books and good lighting. I keep all my pastels and any extra equipment on a trolley, which can be wheeled out of the way when necessary. A plan chest for storage of your papers, materials and paintings is a wonderfully useful item if you have the space. If not, you can store papers and pictures in cardboard or plastic portfolios.

Tip

Before you start to work with your pastels it is a good idea to make your own colour chart (see page 11). On a large piece of paper, or a spiral bound pad, make a mark with each pastel, and write down the name and number. Then, if you remove the wrappers from your pastels (as you should), you will still be able to identify a colour before you use it up completely. This will make replacing a much-loved colour quite easy.

Making Marks

As children, we all used crayons and pencils for drawing and 'colouring in' (generally using the point of the implement) in an uninhibited way. Sadly, along with adulthood come many inhibitions, and we have to relearn how to be playful and experimental. So, before embarking on the slightly scary business of making pictures, I'd like to encourage you to allow yourself to practise with your pastels, making friends with them in a lively, imaginative way. I promise you will enjoy yourself as well as learn a great deal!

As a way of demonstrating the techniques in this lesson I have produced practice sheets based on abstract geometric

designs, as if I was designing a pattern for a scarf or a tablemat. I began by drawing shapes with a fibre-tip pen, and worked the pastel over the top. It's fun to work in this way without the pressure of trying to produce a recognisable object or scene.

Before you begin, I want to emphasise an important point which is the main source of many pastel painting problems. From the start, when practising the techniques in this lesson, make sure to vary the pressure you use as you apply the pastel to the paper. If you press heavily, you will push the pastel particles into the paper, filling and clogging the recesses of the grain. These thick layers of pastel become smooth and slippery, making it difficult to add more pastel without making nasty smeary marks. So, keep your pressure light to begin with, while working freely and boldly.

As you work, find out how the marks make you feel. I know this sounds a little odd, but there is a great deal of difference in the way we make certain marks, and how they make us feel. Making softly blended marks will feel quite different to making little sharp scratchy ones, for example.

Aims

- To become familiar with the feel of pastel on paper
- To discover different ways of applying pastels
- To develop confidence in handling pastels
- To gain experience which will enable you to interpret your subject in a lively and expressive way

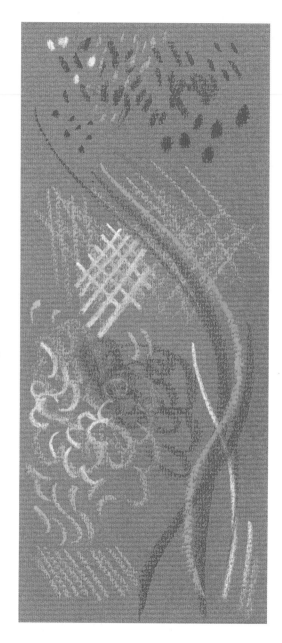

With the end of a soft pastel discover the different marks you can make, such as dots, dashes, curves, circles, straight lines and hatched lines.

Tip

Linear strokes produced with hard pastels or pastel pencils remain crisp and sharp, and these pastels are probably best if you decide to use this technique extensively in a painting.

LINEAR STROKES

By using the point of a pastel you can make many different kinds of marks. You don't need to use a pastel pencil to create thin lines and tiny dots; even with a thick stick of pastel in your hand, you will find that you can make the smallest and finest of lines and dots.

Linear strokes can be used not only for lines, but also to develop areas of texture and colour in various ways. Cross-hatching is the technique of overlaying lines closely over each other; feathering is applying small vertical lines alongside each other; scribbling is whatever you want it to be; stippling is an area of tiny dots of colour (the more space between the dots, the less intense the effect of the colour).

Copy the different types of marks I have made on this page, and then see if you can find any other ways to use the point of the pastel. Remember that different types of paper cause the quality of your strokes to vary – a rough paper, for instance, will break up the strokes.

Draw a simple design with a fibre-tip pen on a sheet of pastel paper, select a handful of pastels in colours that appeal to you and use linear marks to create patterns while exploring the variety of marks. Remember to vary the pressure on the pastels.

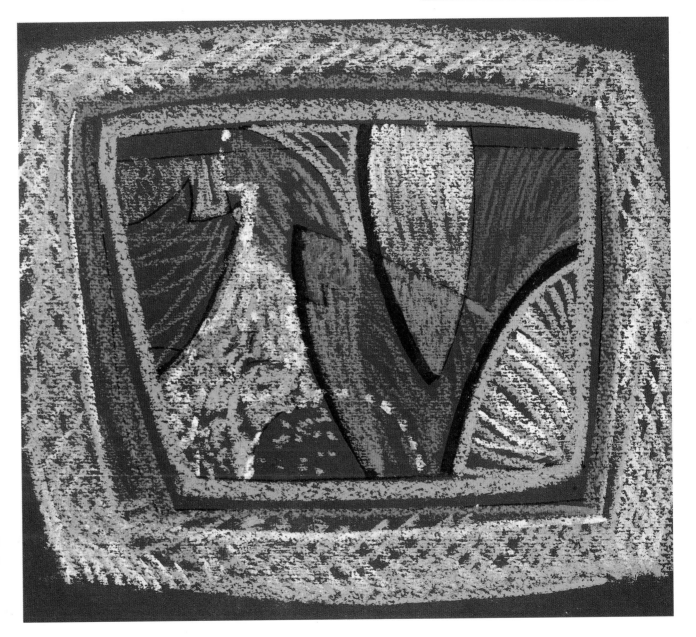

SIDE STROKES

Before you go any further – take the wrapper off the pastel and break that stick in half! You might hate to do this, but you will never relax enough to use your pastels properly if you do not. Now simply press the side of the pastel against the paper, and sweep it across the surface. In this way you will be able to cover large areas quite quickly. If you press hard, you will fill the paper surface to give a dense finish; with light pressure, the colour of the paper will sparkle through the pastel particles. As well as stroking simply from left to right, twist your wrist too, to see how you can vary the stroke, as I have done in the examples on this page.

Side strokes of pastel can be layered or scumbled over underlying colours if you use a very light touch, allowing the colours beneath to show through the top layers.

You should discover that working with the side of the pastel feels very different from working with the chisel edge of the end of the pastel. Stroking pastel on in great sweeps of colour is wonderfully liberating! It is good, sometimes, to stop and think about how certain techniques make you feel. If, for example, you want to create a quiet area in a picture, it might be better to use simple side strokes, rather than a hectic mass of lines and dots!

You can create bands of colour like those at the top by sweeping the pastel across the paper from one side to the other; the livelier strokes like those below are achieved by holding the side of the pastel flat against the paper, and twisting the wrist as you spread the colour across the paper. Vary the pressure of your strokes so as to achieve dense, and less dense, marks.

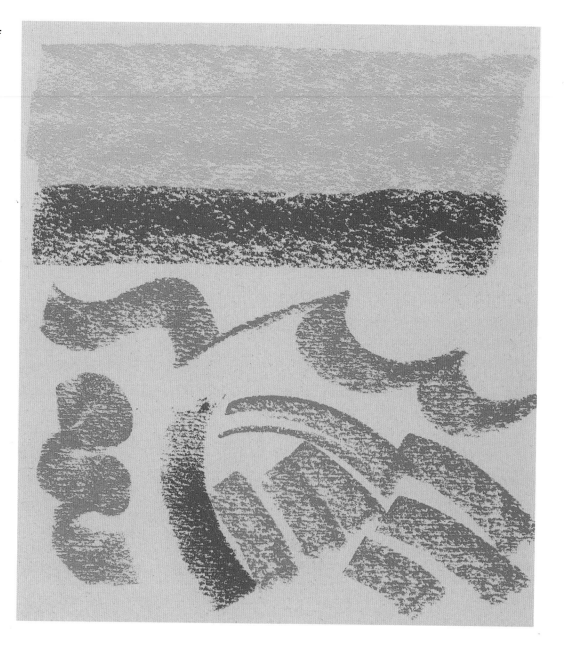

The width of your side stroke will depend on the length of the piece of pastel you use. The blue strokes at the bottom of the picture were achieved with a larger piece of pastel than the orange and cream swirls at the top, which were made with small, broken pieces of pastel. I used a brown fibre-tip pen for the underlying drawing, but you could use any colour.

Tip

The little vertical lines in the image are caused by the laid lines in the Ingres paper. If you don't like these lines, always be sure to hold the paper to the light when you buy it – if you can see the lines, buy another type of paper!

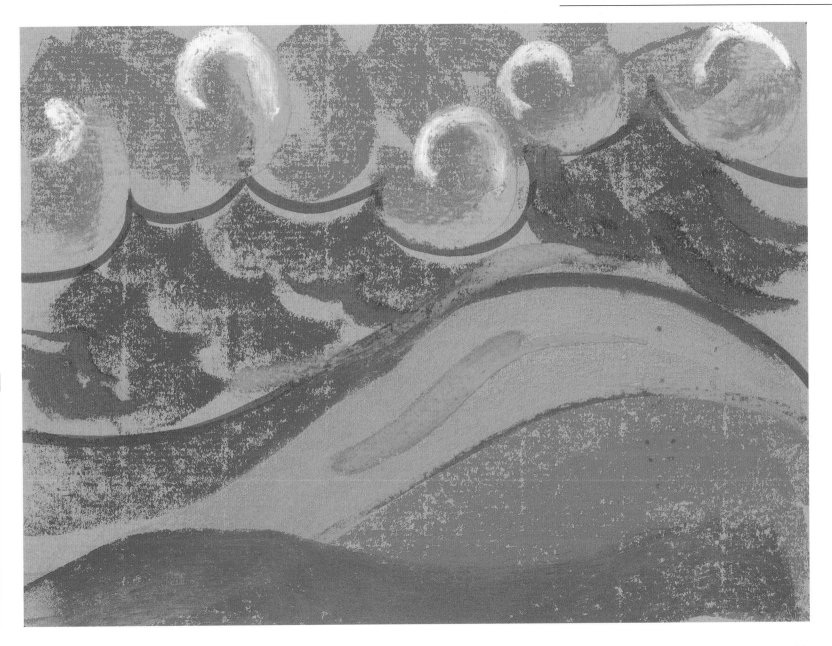

BLENDING

There are various ways of blending your pastels to achieve a velvety, uninterrupted finish. This can be useful for achieving atmospheric effects, for softening edges, and for establishing smooth surface qualities. Large areas can be blended with tissues or even a rag, while small areas and edges can be merged and blended with fingers, cotton buds, or a torchon.

Different techniques produce different results – blending with a tissue removes pastel, whereas blending with fingers or your hand presses the pastel into the paper and produces a denser result. However, a word of warning: too much blending in a picture leads to a rather dull, overworked look. This is because unblended pastel marks on the surface of the paper catch and reflect the light, and if you rub and blend every mark, you will lose this special quality. My advice is to use a combination of blended and textured areas in a picture, for more impact and interest. Also, be selective about your use of blending – it might be suitable for clouds, for instance, where you want subtle colour and softness, but it wouldn't necessarily be quite so useful for a textured area of foliage. Having said that, blending works well if texture is then added over the top.

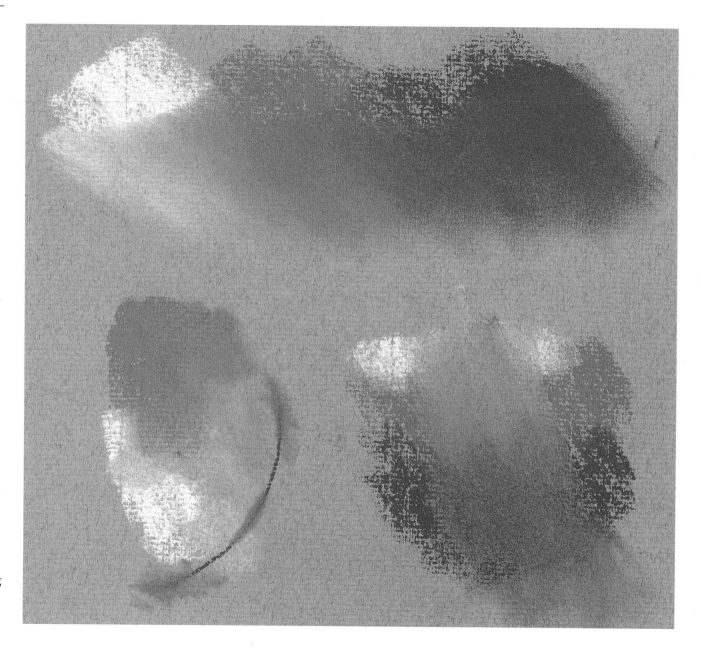

Opposite Notice the different effects you can create when you blend pastels with your fingers *(top),* with a torchon *(below left),* and with a tissue *(below right).*

Right If you want to produce a similar design to this one, scrub the pastel on loosely, working to a geometric pattern and using a variety of colours in each area. Then, use your fingers to blend. You may find that you need to use different fingers for different colours, or you will transfer colour from one part to another! Over the top of the blended geometric design, use some simple lines of pastel for a little contrast.

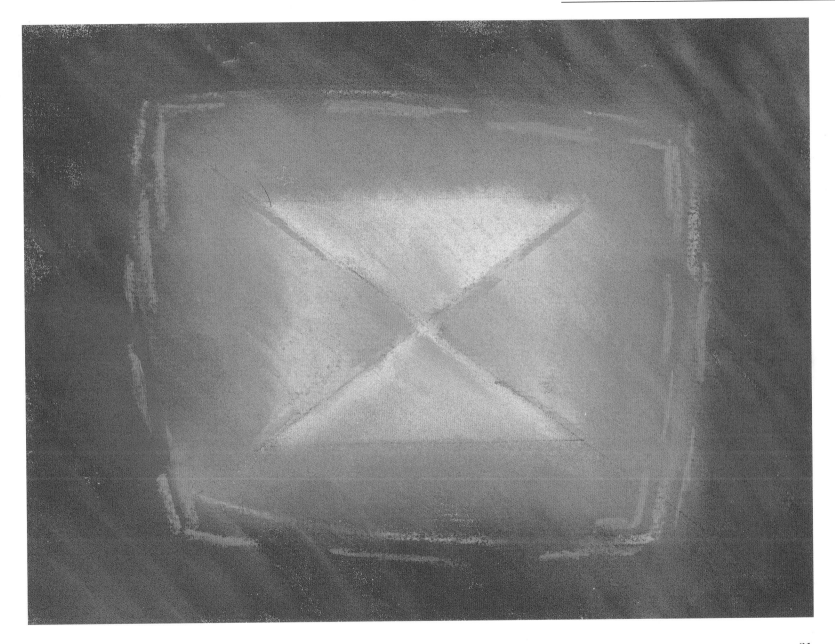

BROKEN COLOUR

The technique of working with broken colour will produce lively pastel effects in a picture. It is a method of building up coloured areas with short strokes, juxtaposing two or more colours, or using similar colours to make a far more interesting visual statement than you could achieve with a single hue. You need to be careful not to use too many colours together in a slapdash way, as this may result in a general effect of muddiness when viewed from a distance.

Also, be careful not to use too many different light and dark tones within an area of broken colour. A very pale blue used together with a very dark blue, for instance, may just look spotty, even from a distance, whereas close tones of different medium blues will blend together visually – look at my examples on this page from a distance. The paper can be allowed to play a part too, providing an element of additional colour harmony, or contrast, depending on the tone and colour of the paper you choose.

You can build up areas of broken colour on any surface, but it is a particularly useful technique when working on sandpaper or pastel board, which grip the pastel strokes cleanly, and are less receptive

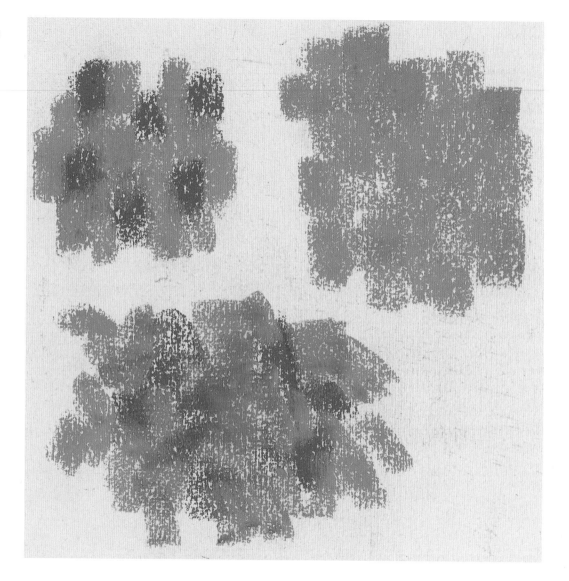

Use small vertical side strokes worked together to produce an area of broken colour *(top left and right)*. Then see how the strokes can be varied in direction for a rather more interesting effect *(below)*.

to blending techniques because of their textured surface (see page 118). Many contemporary pastel painters use broken colour in their work to create vibrant, dynamic images. For inspiration and ideas look at Degas' paintings, and at the pastel work of Toulouse Lautrec.

Using the bottom of a wineglass as a template, make random circles on pastel paper with a black fibre-tip pen by running it around the circular base of the glass. Then use short strokes of broken colour to fill in the shapes, working over the circles in places.

It is interesting to notice that because the circular shapes of the design go off the paper they give the impression of being part of a larger image. To create a similar design, but with more variety, use circular templates of different sizes (perhaps a plate and a saucer) as well as the wineglass. Alternatively, if circles don't appeal to you, you could draw around boxes, or you could even draw the shapes of various types of jug, or bottle, or leaf, onto pieces of card, cut them out, and use them as templates, allowing the shapes to overlap each other in places. Have fun experimenting, with a purpose.

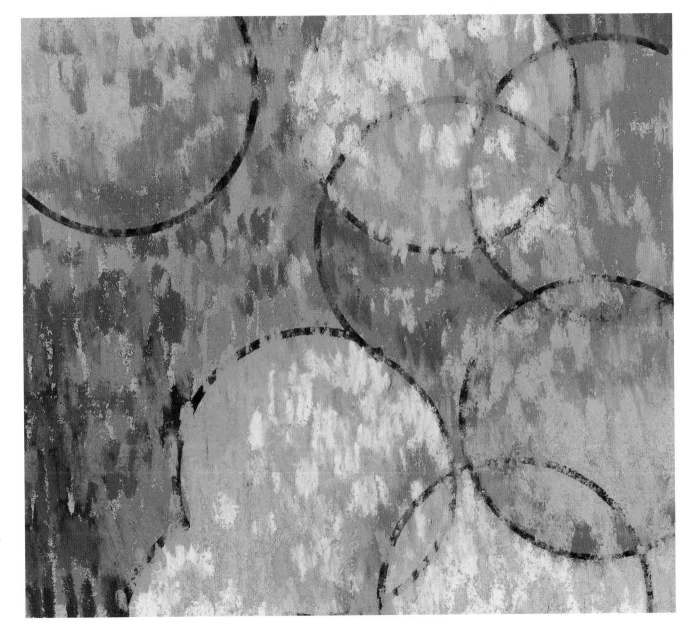

FROTTAGE

Although this technique is not much used with pastels, I thought you might like to try it for fun. You can achieve an interesting range of textural effects by placing your paper over a textured surface, and rubbing with your pastel. I suggest you begin with the thinnest pastel paper you can find; Ingres pastel paper is thinner than most. Alternatively, you could use brown parcel wrapping paper, or white cartridge paper. (You can colour cartridge paper with an old teabag if you wish.)

The finished effect of a frottage experiment may surprise you, since it isn't always what you'd expect! As well as working with one colour and texture, try shifting the paper slightly as you work, and changing the colour of your pastels. You might use the pastels on their sides as well as their points for different effects, and try hard pastels as well as soft ones, if you have them.

See how many textures you can find around your home. As you can see from the examples on this sheet, you do not need to go far to discover objects that will give fascinating results.

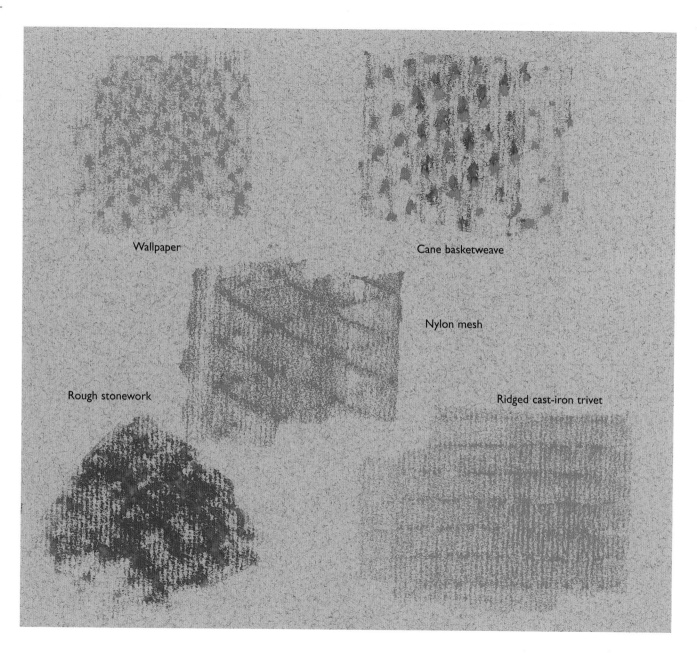

Wallpaper

Cane basketweave

Nylon mesh

Rough stonework

Ridged cast-iron trivet

COMBINING MARKS

Now that you have tried various methods of applying pastel to paper, it is time to try combining the different types of marks to see how the different effects work together. You may find, for instance, that although it is easy to develop lines and textures over blended areas, it does not work in reverse.

I suggest you make written notes on your practice sheet to describe how you achieved your results. Keep these sheets to refer back to, so you can remind yourself how to recreate certain effects – this can be very useful.

Also, when you feel confident with the different techniques, try them out again while at the same time trying to produce gradations from light to dark. This is a useful technique to learn, since it will help you when you try to create, for instance, the fullness of rounded forms, or subtle transitions of tone.

I worked with a variety of reds and oranges on a dark brown paper, which shows through in places. All the techniques that we have looked at in this lesson (except frottage) are shown here – see if you can identify them. Then produce your own sheet of marks to incorporate all these techniques.

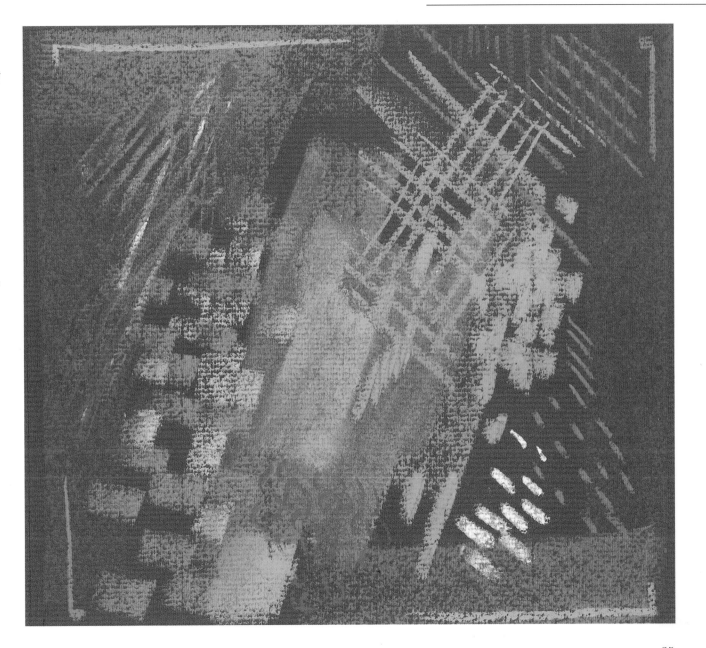

MAKING CORRECTIONS

Sometimes I find it jolly difficult to get my shapes and proportions absolutely right first time – and then I bless the day I discovered pastels, because they are so easy to correct.

If you haven't been too heavy-handed, you can work over a shape or area with subsequent layers to correct it, and this can produce interesting results as previous layers can be seen sparkling through from below. However, as we have discovered already, a build-up of pigment on the paper will become heavy and unworkable eventually, and then the alternative is to remove the pastel from the area and rework the painting. Soft pastel can be removed very easily, and this is where your hogshair brush comes in useful: simply brush off the area you are unhappy with, and blow away the pastel dust as you do so. You may then find a slight stain on the paper, and if you would like to remove this too, press a putty rubber repeatedly onto the paper, and rub gently – this will remove any remaining traces of colour. It really isn't necessary, however, to work right back to the colour of the paper, since you will obviously apply more pastel in due course. Most pastel papers are fairly sturdy, and will not be damaged at all by the action of the putty rubber, but it is wise to be fairly careful. I never worry about a drift of colour left on the paper – I simply work on over the top.

Another method of removing heavy layers of pastel is to scrape gently down the paper with a safety razor blade. I have seen artists removing pastel in this way, but I am rather nervous of the blade, and prefer to use my brush!

Create a simple two-colour circle like mine (1). Remove half of the circle, first with a brush (2), then with a putty rubber, take off the remaining hint of colour (3). Using the eraser is not strictly necessary – you will be able to work easily over the brushed-off section (4).

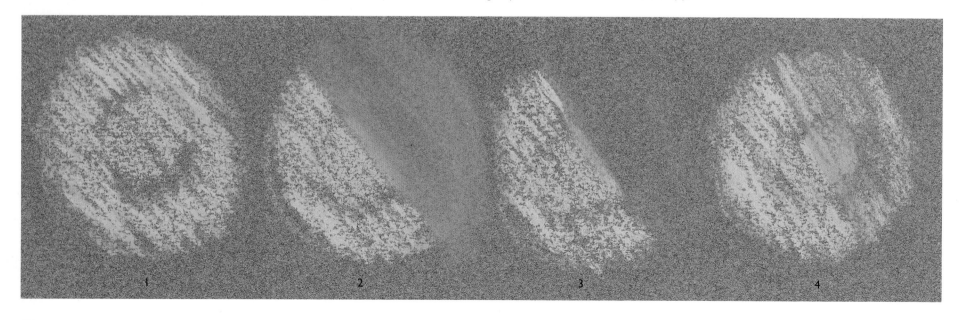

1 2 3 4

USING FIXATIVE

Some artists fix their work while others don't recommend it. I say that if Degas used fixative (and he did) then it must have some merit! Let's explore its good and bad points.

Fixative will help to fix the pastel particles to the paper. This sounds appealing, but it must be remembered that fixative is a varnish, which, if applied heavily, will dampen the pastel particles causing them to merge together, muddying and dulling the surface. The colours will also darken slightly, as I have shown in the example on this page.

Before spraying fixative onto your picture, always test the spray on a blank sheet of paper first. Sometimes a spray can be faulty, or the nozzle will clog slightly and deposit large spots of fixative on your painting, which will leave dark marks. What you want is a fine spray with no big wet blobs. Lay the picture flat and use the spray very sparingly, holding the can about 30cm (12in) from your paper.

I occasionally use fixative as Degas did, during the progress of a picture, when I want to work over the top of previously applied layers. A quick burst of fixative will restore the tooth (texture) to the surface and allow more pastel to be applied. I also use fixative's darkening quality in order to tone down an area which I feel is a little too bright – fixative can sometimes be a useful tool.

When I have finished my picture, I usually give it a short spray of fixative. This will afford a little extra protection, but it is still possible to smudge the picture, so it must be framed under glass, or covered with either tracing paper or acid-free tissue, as soon as possible.

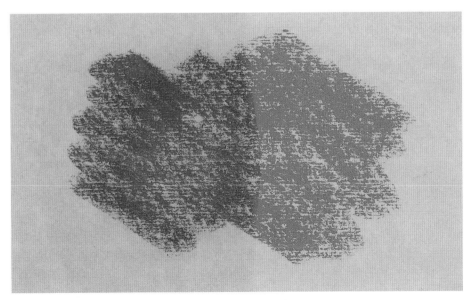

I covered the right-hand side of the blue and sprayed lots of fixative on the left. See how it has darkened the colour.

I fixed the blue lightly, and was then able to work pale blue and white over the top without picking up the darker blue. Try a similar exercise for yourself.

Inspiration from a Master

For centuries it has been common practice for art students to copy, or 'transcribe' the work of a master painter in order to understand more about the way the finished result was achieved, and to practise the techniques used. As a student, I was encouraged to copy the drawings of masters such as Rubens and Dürer, being faithful to every single line! This taught me a great deal, and I heartily recommend it as an absorbing and extremely educational way to spend a rainy afternoon.

In this lesson I suggest that you try a similar approach in order to familiarise yourself with pastel techniques in the context of a fully-formed image by repeating my pastel version of a Van Gogh oil painting. I have used the word 'repeat' rather than 'copy' deliberately, as it is not necessary to copy mine exactly. The reason

Aims

- To transcribe a painting by Van Gogh
- To practise techniques as you work
- To develop confidence with pastel techniques in the context of a picture

I have chosen this image for you to use is that Van Gogh used writhing, rhythmic marks throughout the picture to animate the sky, hills and trees. The three-dimensional form is somewhat subdued, making us even more aware of the mark-making aspect of the picture, which gives it its energy and power. This approach lends itself well to practice with pastels, and copying the work will free you from the worry of producing an idea of your own, and then battling with the problems of composition, colour and form. I want you to concentrate on the mark-making aspect above all else, and enjoy the experience of painting!

Ideally, it would be best to work a little larger than the pictures here, giving you plenty of opportunity to practise techniques without feeling cramped. Try drawing the main shapes of image freehand at a size of about 27 x 21cm ($10^1/_2$ x $8^1/_2$in) – it doesn't matter if they are slightly different, since they are already so stylised – but if you are a little nervous about doing this, simply trace the outlines, enlarge the image on a photocopying

machine, and trace it down onto a sheet of pastel paper (see tip).

I tried to be fairly true to Van Gogh's colours, but you do not need to worry too much about being totally faithful to the colours I have used in my palette – just do your best to use similar colours. When you have moved on in this book, and looked at the lesson on colour (see page 44), then come back to this lesson and examine this image with the benefit of your new understanding, considering colour as an independent issue – you will see that the colours Van Gogh chose were not arbitrary at all.

Exercises of this type have real value for the beginner, so don't hesitate to use other master paintings as a learning tool, in the way that you have done here. You haven't simply copied an image – you have used the image to help you to develop your skills and confidence. You cannot fail to learn from a master, and what you learn will underpin the work that you do from life.

Tip

Make your own tracing-down paper by spreading some charcoal on the back of the paper of your traced drawing, blending it with the fingers, then redrawing over the top of the original lines to transfer charcoal lines to the pastel paper.

Alternatively, buy a wax-free graphite tracing-down paper (available from art shops in various different colours). This product allows for the tracing to be painted over easily, and erased without smearing.

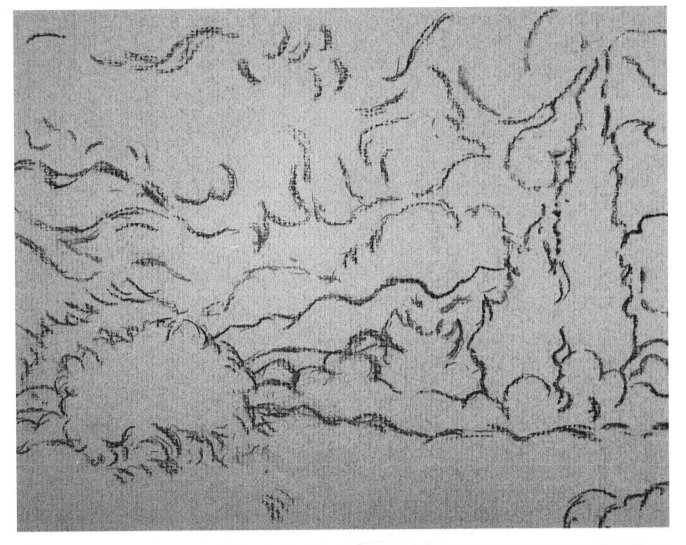

REPEATING AN IMAGE OF VAN GOGH'S *CORNFIELD AND CYPRESS TREES*

This exercise will give you practice in working with linear strokes and stabbing marks, and will demonstrate what a lively result you can achieve without using any blending at all. (Blending is the technique probably most associated with pastel, and it is very seductive as the results are so immediate and effective; however, too much reliance on blending can lead to an overworked, smeary picture. Don't worry – you'll have plenty of chance to try it later on!)

Try to match the colour of the paper and the palette colours (shown at the bottom of the page) as closely as possible for this exercise.

As you work, try to keep the heel of your hand off your work, or it will smudge. Pastel and charcoal are always best worked with your drawing board at an angle so that particles drop down and away.

STEP 1

On a neutral grey pastel paper, trace down, or draw freehand the outlines of the image, using charcoal (as I have done), or pastel pencils. If you are worried about losing the outlines, spray them with fixative (see page 27).

STEP 2

Using small linear strokes of dark green, work on the cypress tree and bushes, twisting your wrist to make the marks curve as you work. Block in the distant hills with medium blue, using either side strokes or cross-hatching, and use the same blue in the clouds.

Notice how the pastel covers the charcoal easily. If you had used pencil, you might have had difficulty covering the shiny pencil lines, as they sometimes 'resist' the pastel particles. It is always a good idea to use charcoal for initial drawings, as it is so easy to lift and remove – a simple wipe with a piece of tissue will remove most of the mark, and the rest, if you wish to remove it, is easily removed with a putty rubber. However, this isn't strictly necessary, as the pastel covers the charcoal completely.

STEP 3

Using curving linear strokes, work on the green
bushes and the tree again, this time using the two
medium greens. Break a short piece off your yellow
pastel, and using it on its side, with a light touch,
block in the foreground with diagonal strokes. Also
using the side of a small piece of purple-grey pastel,
make curving strokes for the clouds, and allow
your marks to overlap the blue in places – you will
find that the purple and the blue will mix slightly,
which is fine. Use a lighter blue over the hills to
suggest undulating form, and use tiny stabbing
strokes of this blue in the stunted tree on the left.

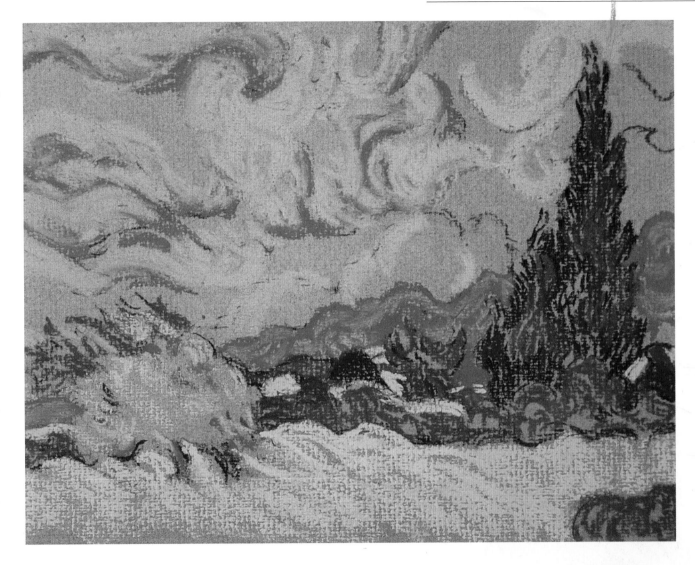

STEP 4

Block in the turquoise sky between the clouds, and don't worry if your colours overlap a little in the sky – they will blend together, which is good. Use the same colour in tiny linear strokes in the small foreground tree. Switch to a white pastel, and complete the clouds, allowing the white to overlap, and mix with the purple and blue. Use the white over the turquoise too, to soften the colour in places and break it up a little. Work on the cornfield with small strokes, dots and dashes of orange and then brown, to suggest the wind moving the surface. Complete the picture with details: using your lightest green, define some of the foliage a little more; returning to your darkest green, sharpen up with small curving lines here and there. Work over the distant hills once again with light blue, leaving touches of the existing colours showing. Notice that there are tiny touches of blue on the ground under the left-hand tree, which subtly suggest shadow.

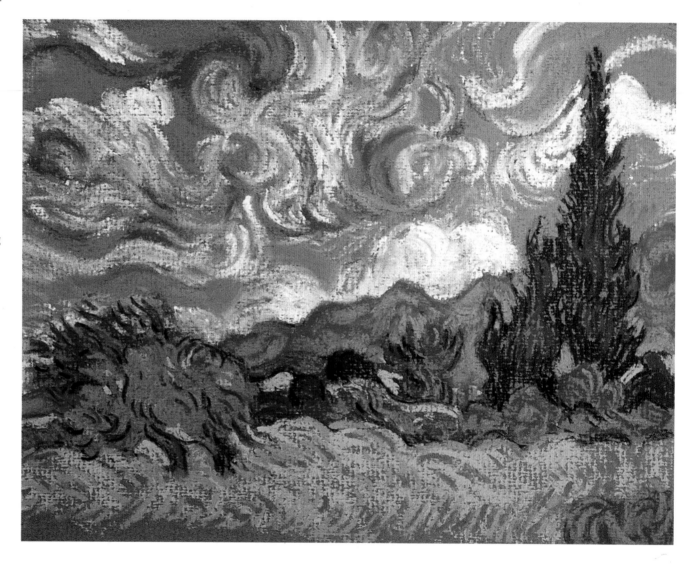

MARKS AND MOOD

Van Gogh painted the image of the cornfield and cypress tree in the late summer of 1889, the final year of his life, while a patient in an asylum. It seems reasonable to assume that the turbulent movement within the image echoes the turmoil in his mind. I wonder if you sensed this as you worked.

The image shown on this page is my transcription of one of Cézanne's Mont Sainte Victoire paintings. It provided a good opportunity to use the technique of broken colour to give a similar effect to Cézanne's brushstrokes (besides which it was great fun to do).

It is interesting to compare landscape paintings with photographs of the actual site. In this case, it will help you to understand some of the more abstract passages in the picture.

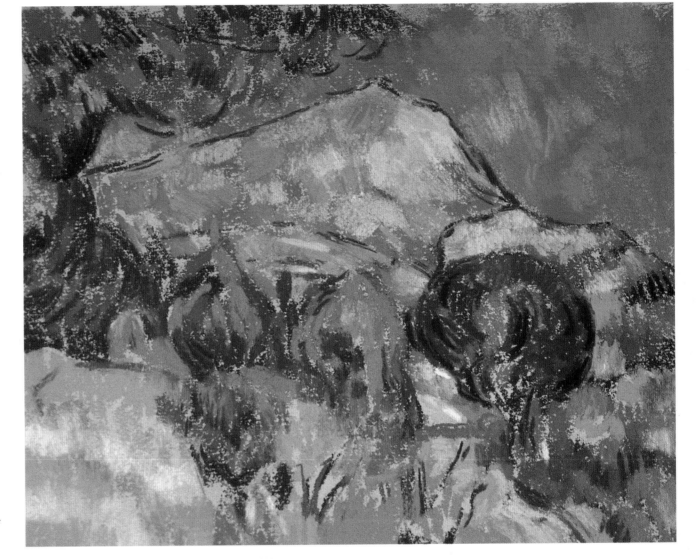

Right Transcription of one of Cézanne's paintings of Mont Sainte Victoire.

First Steps in Shape and Form

If you aim to be a representational painter – that is, to paint what you see – then you simply must practise drawing. I can't stress this strongly enough. No amount of wonderful colour and clever techniques will rescue a painting in which the objects are all out of proportion.

USING A SKETCHBOOK

Start a sketchbook immediately and sketch as often as you can. If you worry about criticism, don't show your efforts to anyone. I promise that, once you have worked through this book, you will be well on the road to improvement. Try all sorts of sketching tools: pencils, dip pens,

fountain pens and fibre-tip pens, and as soon as possible, begin to work with charcoal. It is a bit messy, but because it is so similar to pastel, it is a good sketching tool for the would-be pastellist. Sanguine conté crayon is also wonderful for sketching, producing a red chalky mark. Both charcoal and conté can be blended with fingers and are easily removed with a putty rubber.

As well as using a sketchbook with white paper, it is worthwhile having a second

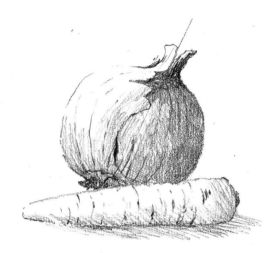

Left Tiny lines of soft (4B grade) pencil shading help to create the form (the sense of roundness) of the vegetables. The softer the pencil, the easier it is to develop areas of shading, either by drawing lines with the point as I have done, or by using the side of the pencil lead, holding the pencil flat against the paper and scribbling.

Below The cat was drawn with a charcoal stick, smudging gently with a finger to make the fur look soft, and then pressing hard for the darkest marks.

sketchbook of pastel paper, so that you can practise working on a coloured ground (and begin to make use of white pastel or crayon to represent light areas). Study the drawings on these pages to see how some of these materials can be used for sketching before we move on to look at how to develop three-dimensional form.

Right The mushrooms were sketched in sanguine conté crayon and charcoal pencil. The shading was done with fine lines in sanguine; the black was added last.

Aims

- To begin to work with sketching materials
- To begin to explore light and form
- To discover how the colour of the paper affects your work
- To paint a simple monochrome still life
- To use different pastel techniques while working, to reinforce previous learning

This five-minute sketch was made with charcoal on white paper. I used the side of the charcoal, skimming it lightly over the paper for the overhead leaves and the darkest parts of the ground – you can see the texture of the paper in the foreground. I used the point of the charcoal to draw the trees, pressing quite hard for the darkest parts of the trunks. A putty rubber can be used to pick out the white paper again if you need to. If you want really black areas, it helps to fix the sketch and then to work into it again.

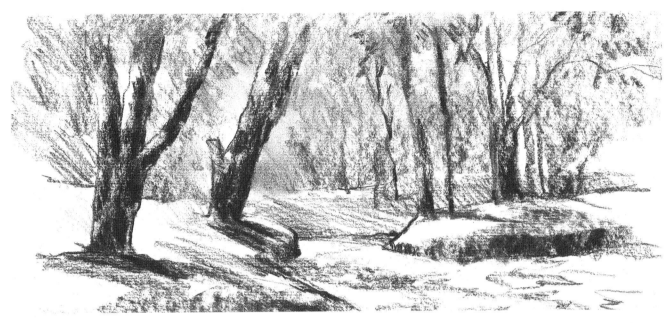

Working with black and white on a toned ground is the closest thing to working with pastels, because you really begin to learn how to use tinted paper. You have to make clear decisions about which are the lightest parts of your scene, and use white to represent the lightest areas. Black then represents the darkest parts; the paper colour is a middle tone, and lightly applied black on the hills behind the house represents another subtle middle tone.

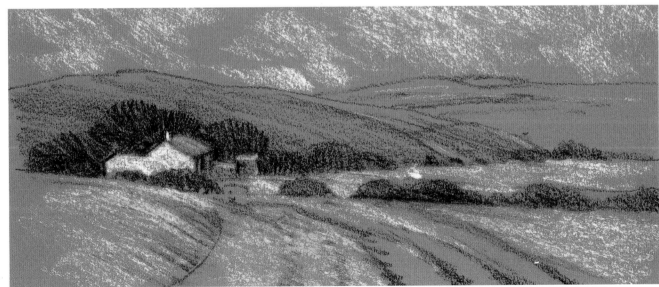

WORKING ON COLOURED PAPER

I am often asked by beginners how to know which coloured paper to use, but there is no simple answer: it is largely a matter of personal choice. Neutral, mid-toned papers are easiest to work on because they are unobtrusive. If you deliberately select a very dark or very light piece of paper, or a strong colour, unless you cover every bit of paper with pastel pigment, the paper colour will show through and will have a great impact on the atmosphere of your image.

There are a few rules of thumb that I can offer about choice, but these are only a very rough guide, since so much depends on the colours within your image. For instance, if you want a very light image, choose a pale paper; if your image is mostly dark, or has lots of dark areas, it helps to work on a dark paper. A dark paper will also give you maximum sparkle and drama in your work. A warm paper colour will add a little warmth to a cold scene or to a scene painted with mostly cold colours (pink or umber provides hints of warmth under a largely cool green garden scene or an icy snow scene, for instance). Neutral pearl greys and mid-toned umbers work well with almost every image.

A light-toned paper makes even pale colours look quite strong, and its texture shows clearly through the darkest colour, illustrating that painting a dark picture on a pale paper would be quite difficult.

A very dark paper contrasts strongly with the lightest colours while the dark purple almost disappears.

A cool mid-blue paper contrasts strongly with the warm orange and harmonises with the purples; the overall effect is cool.

The reverse applies here; a honey-coloured paper harmonises with the orange strip, but contrasts strongly with the purples. The overall effect is much warmer than the blue background.

Tip

Very few coloured papers are totally light-fast, so it is usually best to cover most of the paper with pastel, in case the uncovered parts fade.

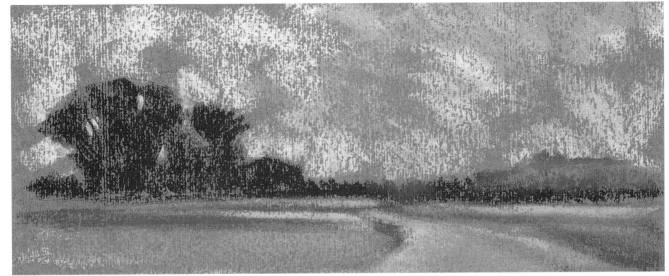

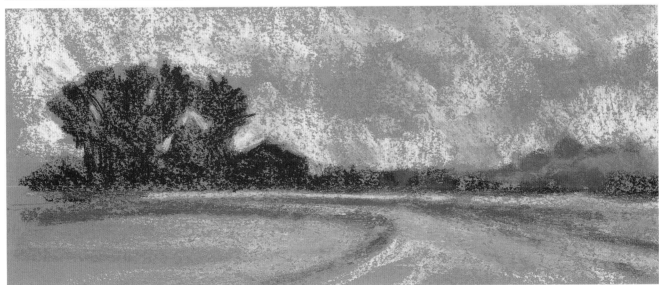

It is fascinating to see how the colour of the paper affects the mood of the image. I used the same four pastels for both these imaginary landscapes, yet the one painted on a grey paper (*above*) is quite different in feeling from the one on terracotta paper (*below*), which appears to have been painted at a totally different time of year. Even the colours seem slightly different – the dark brown used for the trees looks darker and colder on the grey paper.

I suggest that you try a similar exercise. Copy my images if you wish, and make sure that the colours of the two papers you select are very different from each other.

CREATING FORM WITH LIGHT AND SHADE

So far we have looked mostly at materials and the marks they make. Now it is time to try making those marks describe what we see, and most of the things we paint and draw are three-dimensional. It is not too difficult to draw the shape of a cube or box, because we can see a top, a side and a front facet, or plane, and the lines drawn for the edges show where these planes change. However, when we come to draw or paint a more complex object, such as a circular form, using a simple outline tells us very little – is the circle spherical, like a ball, or flat, like a badge? The only way to inform the viewer that it is a ball is to use

The red outline could represent any circular form, but the shaded circle is definitely a ball.

shading, or tones, to describe the form – giving the illusion of three dimensions. If you aren't used to creating shading, I suggest you practise shading by itself, gradually building up from light to dark, before you try working on objects.

SIMPLIFYING FORM

Whether you work in pencil, charcoal or pastel, always try to break down your object into simple light, medium and dark tones. Squint, to simplify what you see – this will eliminate lots of half-tones, much of the detail, and will help you see the simple pattern of broad areas of light and dark. Once you have established these main tones, you can work more subtle variations into them if you wish. Details such as the fine lines on the skin of an onion, the markings and textures of fruits, and the decoration on a vase, should always be the last thing you tackle. Constantly remind yourself – form first, details last!

As you work, you will discover something exciting. If you have translated the tones properly, you will find that you have discovered how to create the illusion of light falling on your subject.

I suggest that you copy the tonal exercise on the opposite page (using green pastels in light, dark and two mid-tones). Then practise creating form with tones as often as possible, filling your sketchbook with drawings and paintings made from life. It is helpful to make sure that the objects you choose are sitting in good light, ideally lit mainly from one direction.

You should practise this kind of simple still life as often as possible. I used charcoal, and a black and a white pastel pencil. I used the side of the charcoal for the shadows on the table and the shadow sides of the fruits. The pencils were used to pick out the darkest and lightest parts, and the light on the table.

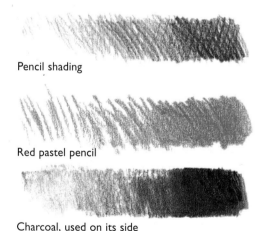

Pencil shading

Red pastel pencil

Charcoal, used on its side

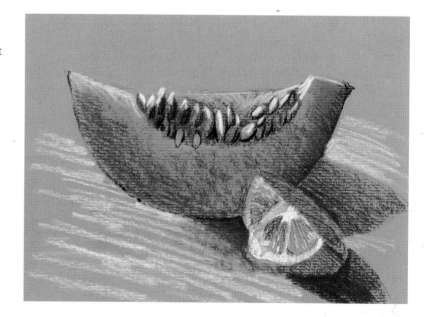

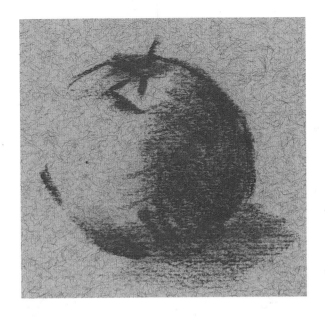

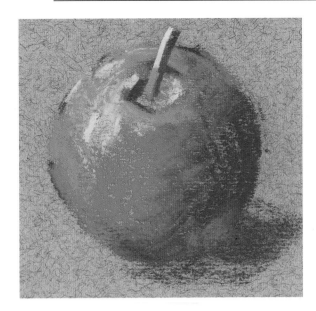

STEP 2

Apply the darker of the two mid-toned greens first, again using side strokes. In places drift this colour gently over the darkest green, stroking a little onto the dark side of the apple just above the shadow, where a tiny strip of reflected light bounces up off the table. Then apply the lighter mid-toned green where the light strikes the apple directly.

STEP 1

Use four tones of green to create this apple, and work from dark to light. Start with the darkest green for the shadow side of the apple. Paint the shadow on the table at the same time. Draw the apple's shape and stalk with the point of the pastel, and then use short side strokes for the shaded area.

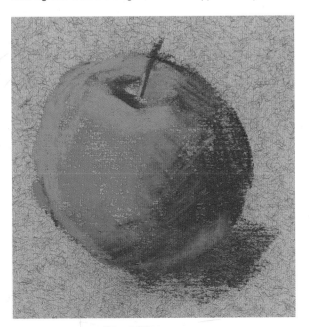

STEP 3

Finally, use the light greeny-yellow for the brightest area of the apple, pressing hard in places to suggest highlights. (It is interesting to notice that very few fruits are completely round like a man-made object – look hard at spherical fruits and you will find a surprising variety in their shapes.)

Tip

If you find it difficult to see changes of plane on a circular form, try to imagine that the object is faceted, like a diamond, and use strokes of pastel to define the facets, allowing the changes of plane to merge slightly at the edges. This will give a convincing sense of roundness.

MAKING A TONAL STUDY:
OLIVE POT AND MUSHROOMS

I suggest that you start by copying this step-by-step demonstration – you could even trace the objects from the second stage on page 41 (step 2), which is the actual size of the picture. Then, however, I recommend that you set up a similar arrangement of your own objects and follow the exercise (as you should with all the demonstrations in the book). This will encourage you to use your own creativity in the selection of your subject, and to put to use what you have learned. Use directional light from a lamp, a spotlight or a window to create strong lights and darks.

We are going to use just five tones; an exercise that will train you to select and simplify. These are excellent skills to acquire, because often the simpler the statement you make, the more impact it will have. I could have fiddled away for ages with extra nuances of tone, but in fact, this little picture says all it needs to say. I chose mushrooms and a natural-coloured pot, so that the colour would not be a distraction, but you could use these five tones for objects of any colour. You will have to 'switch off' the colour in your mind and work in monochrome, as you would with a pencil.

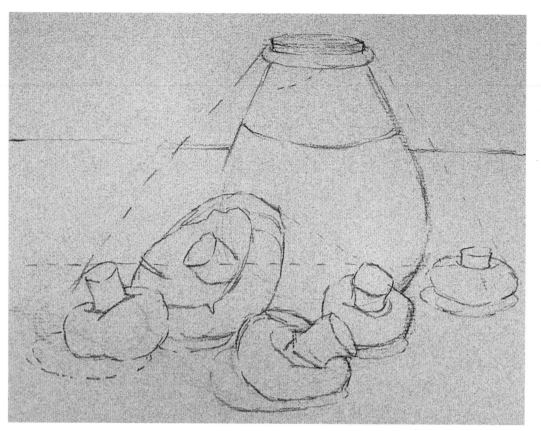

STEP 1

Choose five neutral tones, and number them from one to five (five being the darkest).

On pale blue-green paper, sketch the still life in charcoal, or conté pencil. Use construction lines in your drawing to help you judge where to place the items – if you hold up a pencil you will be able to assess the angles, as I have done, and horizontal lines will show where things 'line up' (or not, as the case may be). It is helpful to develop this skill, rather than drawing around each object and hoping that it will fit into place. When you set up your own still life, be particularly careful to check the proportions of individual objects against each other. Fix your drawing.

Tip

As you work, look hard at each part of the still life. Ask yourself whether each part is darker or lighter than the part next to it, and adjust the tones accordingly.

STEP 2
Using your No. 5 tone, fill in
the darkest parts of the still
life. If your pastel is a new, long
stick, you might find it easier to
break off a small piece for side
strokes, and use these together
with short linear strokes, filling
in gradually. Then use tone 4
on the parts that are not quite
as dark as the first areas you
tackled.

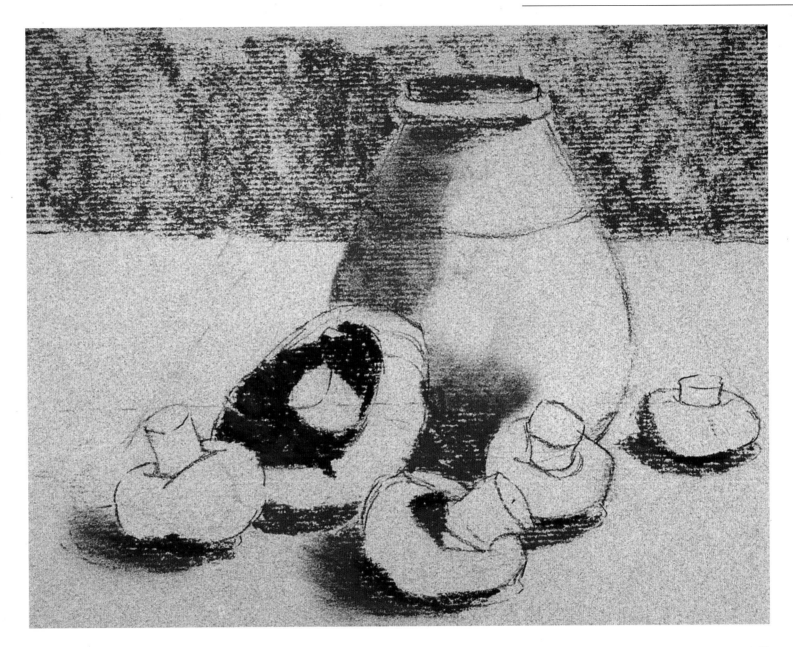

STEP 3

Learning to recognise the intermediate tones is always the most difficult part of this kind of exercise. To do this you should half-close your eyes as you look at your subject. You will quickly discern the darkest and the lightest areas. Now all you have to do is sort out the in-between tones! Using tones 2 and 3, work across the whole image as I have done.

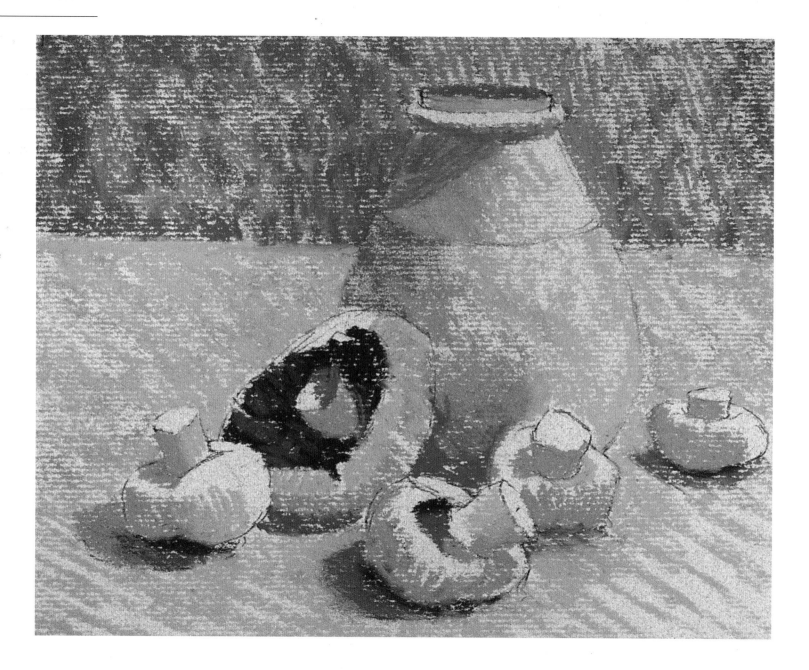

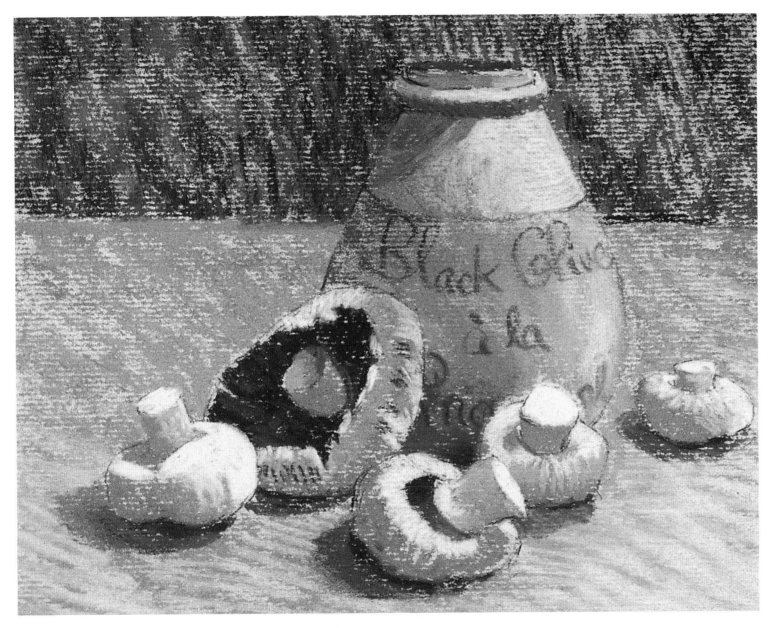

STEP 4

Now you can have fun using your lightest tone (1), using small linear marks in places to suggest the form of the mushrooms, and for the flat tops of the stalks you can press really hard for solid coverage. Stroke this light tone over the lower half of the pot very gently so that you lighten it just a touch, and also across the table top in the foreground – this is cheating a bit, because in fact you are really creating a sixth tone.

Work across the image defining shapes and tones, using the appropriate pastel. Finally, put the wording on the olive pot – use charcoal, pressing gently to create a soft tone that won't stand out too much.

Colour

Painting the colours in nature isn't always straightforward. For instance, a white wall may look yellow in the sunlight and blue in the shadows, and a blue pot next to a red brick wall will reflect the red of the bricks in places. We have to deal with the actual colour of an object (its local colour), reflected colour, and colour modified by the light. With all these difficulties to deal with when observing colour, you may wonder why we have to concern ourselves with colour theories as well. The answer is that simply matching the colours you see does not always give you the effect you would like to achieve. However, knowledge of some of the basics of colour theory will help you to paint colours not just from observation or from intuition, but with understanding and purpose.

TRANSLATING TONE INTO COLOUR

Strange though it may seem, we appear to have little difficulty in taking a coloured object and drawing it, together with its tones, with a black pencil. However, when we start to work in colour, something rather odd happens. Our ability to judge the tones of the colours before us seems to disappear – perhaps because we are bombarded with the lovely colour, we fail to see the subtle nuances of light and dark. What happens then is that our pictures look rather flat, and there is little or no sense of light in the image. We need, somehow, to be able to look at an object or scene, to analyse the tones, and then translate them back into correct colours. This isn't as easy as it sounds, as you will soon discover if you try to create a chart like the one on the next page.

This exercise never fails to amaze my students when it reveals their unrecognised weaknesses. Start by drawing up a grid of squares on a piece of paper, and using

Understanding Colour Terms

Primary colours Pure, unmixed red, yellow and blue.

Secondary colours Two primary colours mixed together will give you a secondary colour.

Complementary colours Colours opposite each other on the colour wheel.

Tone Beginners are often confused by tone in relation to colour. It simply means the lightness, or darkness of any colour. For example, light ultramarine blue is pale in tone; dark ultramarine blue is a deep navy-blue. A painting is sometimes described as having a high tonal key or a low tonal key, which means either a light image, or a dark one.

Temperature In theory, red, yellow and orange are said to be warm colours, while blue, green and purple are cool. However, there are subtle degrees of warm and cool in every colour, as we will see in this lesson.

Neutrals There are really only three true neutrals: black, white, and grey mixed from black and white only. However, pastels come in a huge variety of subtle grey-greens, grey-reds and grey-blues. In pastels, these are mixtures of the three primary colours, in varying quantities, plus white or black. They are, in practice, coloured greys and browns.

Harmonious colours Colours that are found next to each other on the colour wheel.

Local colour The actual colour of an object; for instance, a red tomato, or green grass.

white, grey and black pastel, make a row of gradated tones along the top of the grid. Select colours at random to match the tones below in columns. When you have finished, look at your chart in dim light or photocopy it in black and white. This will show you how well you tackled the problem. You should see uniform strips of grey. Reds can sometimes surprise you – they are often much darker than you think. There are deliberate errors in my chart – can you spot them?

Right With pencil, draw a grid of 25mm (1in) squares on a piece of coloured or white paper. Establish at least seven tones, from white to black in the top row of squares. In this chart, the colour of the paper represents the first light grey. With a random selection of pastel colours, try to match the tones in the columns below, mixing the colours on the paper if you need to adjust tones.

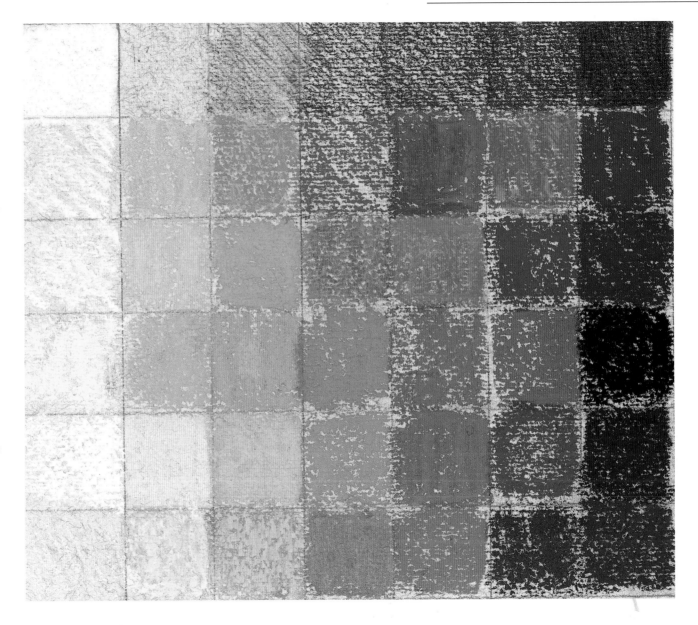

Left Photocopy your chart in black and white to reveal how successfully you have matched the tones of the colours.

THE COLOUR WHEEL

The colour wheel is an arrangement of the colours of the rainbow, or spectrum, in a specific order which enables us to find, quickly and easily, complementary pairs of colours, and colour harmonies, both of which I will explain more fully in the next few pages.

All colours originate from the three primary colours – red, yellow and blue – which cannot be mixed from any others. The other three colours on the wheel – green, orange and purple – are called secondaries, and each of these is a mix of two of the primary colours. If we were to mix all three primaries together, or if we mix a primary colour with a secondary colour, we will have mixed a tertiary colour – which will be a coloured grey, or brown.

Of course, 'mixing' doesn't strictly apply with pastels – we simply pick up the stick we want! However, as we learned earlier, it is possible to create visual mixes on the paper by placing colours side by side, or by cross-hatching one colour over another, so it is important to understand how colours work together when we do this, or we can easily create muddy visual mixtures.

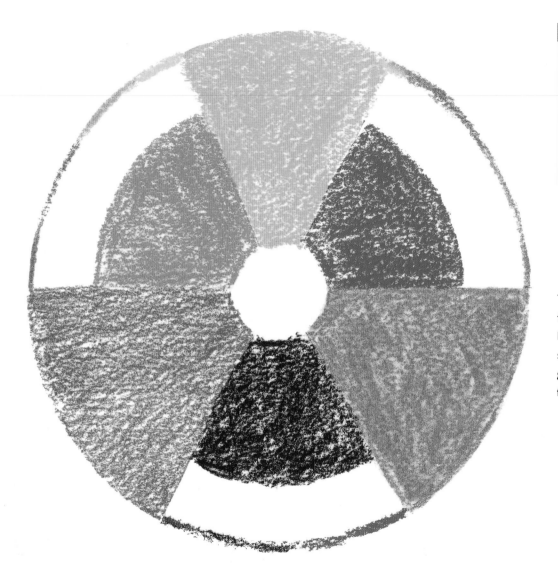

Tip

If you can't remember the colour wheel, I suggest you make one in the back of your sketchbook to refer to.

This is the simplest form of colour wheel, based on the spectrum, and is a guide to the main families of colour.

WARM COLOURS COOL COLOURS

Warmer colours are on the left; cooler colours on the right. As you can see, even yellows and reds, traditionally considered to be warm colours, have cool versions.

WARM AND COOL COLOURS

Being able to identify warm and cool colours, and knowing how to use them, will help you enormously as your painting skills develop. For example, cool colours (such as blues and greens) tend to recede in a painting, while warmer colours (such as reds and oranges) pull forward. Understanding this can be very useful when you want to create a sense of depth, space or distance in a picture. Also, if you want an overall feeling of warmth in an image, you might deliberately choose to use more warm colours than cool ones.

Most successful paintings have a variety of warm and cool areas. Some artists deliberately choose a warm-coloured pastel paper to work on, if they plan to paint a cool picture – for instance, a pink or warm grey-brown paper will add a tiny touch of warm contrast to a painting of a snow scene, or a water scene.

This is quite a lot of information to digest, and it is early days yet, but file it away in your memory bank – you will make use of it in due course. For now, just learn which colours are basically warm, and which are cool. Also, try to remember that

there are degrees of warm and cool in most colours – a look at the colour wheel again will help. A yellow which moves towards green (cool greeny-yellow) will be cooler than a yellow which moves the other way, towards red (warm orangey-yellow). Blue which moves towards green (turquoise) is cooler than a blue which moves towards purple (ultramarine).

These circles prove that a warm colour advances and a cool colour recedes. Try several of your own colour circles, experimenting with different combinations to see what happens.

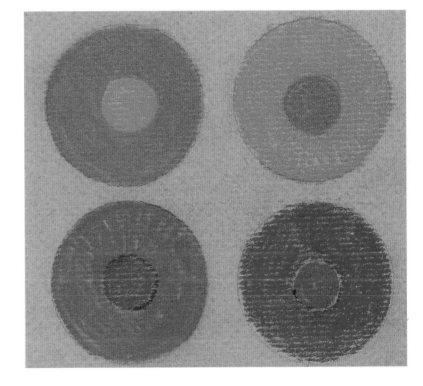

COMPLEMENTARY COLOURS

It is important, even at this early stage, to recognise that you can manipulate colour to your advantage, either by choosing your subjects carefully, or by adjusting colours slightly as you work. Complementary colours – those opposite each other on the colour wheel – intensify each other when placed side by side, and appear almost to vibrate, so if you want to draw attention to a particular spot in a picture, it may help to use complementary colours there.

Pictures that are painted exclusively with complementary colours can be very effective. However, you need to be careful here. If you decide to use complementary colour in a painting, make sure that just one of the pair dominates, and surround it with muted versions of its partner. Otherwise, if you create a picture which is, for instance, 50 per cent blue and 50 per cent orange, it will vibrate so much that it will be really hard on the eye!

If you mix complementary pairs of paints together, you create greys – sometimes called neutrals. Similarly, if you stroke some purple pastel over a yellow, you will neutralise, or 'grey' the yellow dramatically, reduce its brilliance and produce a coloured grey. It is really useful to understand this principle, so that you

can apply it when you work. You can quieten down a too-vivid green in a landscape, for instance, by stroking a little red over it.

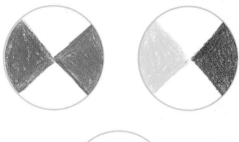

These are the three complementary pairs: red and green, blue and orange, yellow and purple. Refer back to page 46 to see their exact positions in relation to one another on the colour wheel.

Tip

The shadows of coloured objects nearly always contain touches of the object's complementary colour – the shadow of an orange may have blue in it, for instance. Using blue in the shadow will intensify the colour of the orange.

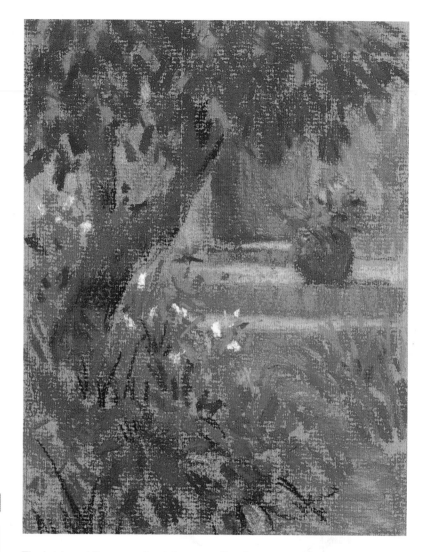

The bright red flowers and red door are offset by a variety of greens in the foliage. Notice, however, that all of the greens are fairly muted. I haven't used any bright green, which would have looked rather garish against the red. There is also far more green than red in the picture, which increases the impact of the red.

COLOURFUL GREYS AND SHADOWS

'Grey' is a term that is used loosely to describe the wonderful variety of greys that occur in nature. Grey patio stones, for instance, can be many different shades of grey, from light to dark. The temperature of the light also comes into play to adjust the colour – sunshine might tint the stones warm apricot-grey, and the shadowy areas might be cool blue-grey.

If you use only one grey or black for all your shadows, your pictures will lack life, light and colour. Shadows are transparent, so using the same solid grey for shadows on a white wall, on green grass, and on a red flowerpot would be ridiculous – yet I have seen students do this, clearly believing that all shadows are the same grey. Careful observation is the key.

Warm light (sunlight, or an ordinary light bulb) will throw cool shadows, while the shadows created by cool light (from an overcast sky or a fluorescent light) will appear warmer. Knowing this will help you to select the appropriate warm or cool colours for your shadows. You will have to decide how you want to apply your pastels, too – different techniques will give different effects. If you are unsure about whether a technique or the colours you have selected will work well enough, practise first on a separate piece of paper.

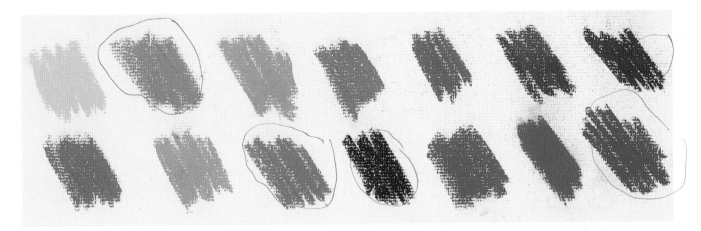

Above Here is a selection of the many colourful pastel greys that you could add to your palette. You will find them very useful for subtle passages of colour in your paintings.

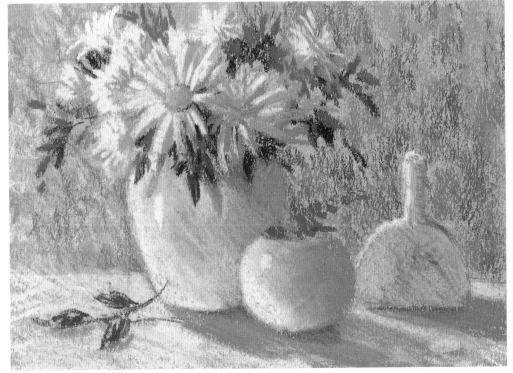

Right The warm light cast cool shadows, so I used a cool purple-grey and blue-grey for the shadows, and warm pale cream and yellow with a little white for the light-struck flowers, china and table. The colours are subtle, but the image is much more interesting than if I had simply used a plain neutral grey and white.

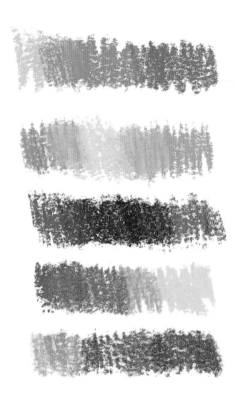

These strips are examples of possible colour harmony palettes.

COLOUR HARMONY

Perhaps the simplest way to achieve harmony in a painting is to use harmonious colours – that is, colours that are next to each other on the colour wheel. In this way, you will be using a limited palette, which virtually guarantees colour success. It sounds strange, but it is fairly true to say that the more limited your palette, often the stronger the impact of your picture. This is because using colour harmonies gives your picture an overall look of unity that is quite difficult to achieve in any other way.

Take a look at the work of the masters – they fully understood colour harmonies, and used them all the time in their work. See how many illustrations you can find where the artist has specifically used a palette of colour harmonies. This can provide an excellent way in which to develop your appreciation, knowledge and understanding of colour.

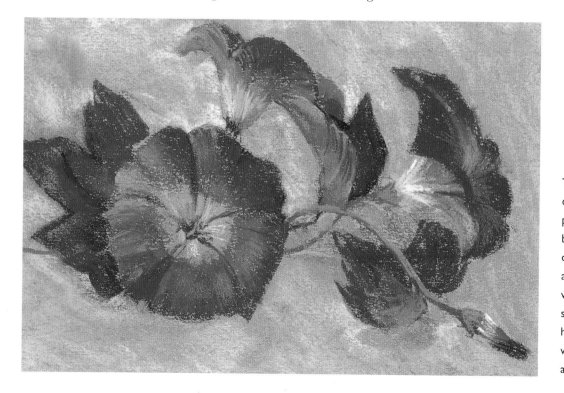

This picture was created with a limited palette of harmonious blues and greens. The colour of the paper is also blue, in keeping with the overall colour scheme, but I could have worked on a warm paper colour to add a little contrast.

MIXING BY OVERLAYING COLOUR

One of the nicest things about working with pastels is the fact that you can create wonderful areas of colour, where glints of previously applied colours show through subsequent layers. Because most pastel papers and boards are textured, it is quite easy to stroke one colour over another, and the textured surface will ensure that even a heavy stroke of soft pastel will skip across the bumps, leaving hints of colour showing through underneath. As you can see from my examples, there are various ways of applying layers – and whatever method you choose, don't forget that you can always use a quick burst of fixative between layers if you are worried about disturbing the underlying colours (see page 27). The areas you create will vibrate with colour, and you can achieve some unusual visual colour effects in this way.

If you have both hard and soft pastels, it is best to begin with the harder pastels and use your softest pastels over the top. Soft pastel will glide over strokes of hard pastel, whereas hard pastels will create grooves in areas of soft pastel.

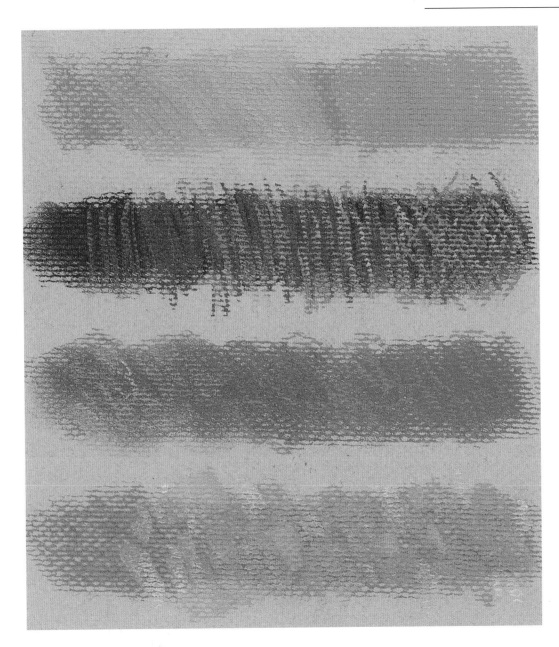

Side strokes of orange and pink are glazed over red by stroking gently with the side of the pastel.

Blues, greens and pale lilac are feathered and cross-hatched over purple.

Yellow, green and pink are scumbled over blue.

Various pinks and oranges are applied as broken colour over brown.

FRUIT SALAD

This little still life shows the use of colour harmony. The fruits that have been chosen have colours which are side by side on the colour wheel: red, orange, yellow, yellow-green and green. The warm light from a spotlight warms the white cloth and creates cool shadows on both the cloth and on the fruits themselves, giving an opportunity to use warm and cool versions of both red and yellow. I chose a cool blue-green paper to work on, which is a complementary contrast to the reds and yellows, and also a temperature contrast. The theory (and action) of complementary colour is also at work elsewhere in the picture – look at the strawberries – red fruits with green leaves attached, making them particularly eye-catching!

Make a copy of my 'Fruit Salad' arrangement if you wish, before setting up something similar to try for yourself. When you select your palette, try to choose pastels that are as close as possible in colour to the fruits you use. Look hard to see where the colours of the fruits reflect down onto the cloth in places, and perhaps even onto each other. And note that, although I have done my best to create this effect in my picture, it is possible that the subtle nuances of colour may be lost in

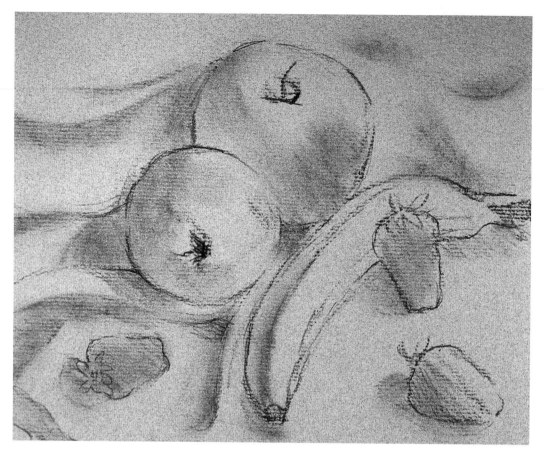

reproduction. A green apple, for instance, would reflect some of the red from a red apple, and vice versa.

STEP 1

On cool blue-green paper, sketch the objects and the folds in the white cloth. Using the side of the charcoal, create the shadow areas of the still life. With a finger, soften the charcoal into the paper (the pastel will cover the charcoal so there is no harm in doing this, and you may find it helpful). Work lightly, and dust off excess charcoal with a tissue. Fix the drawing.

Tip

A quick way of checking your composition is by looking at it through the viewfinder of a camera.

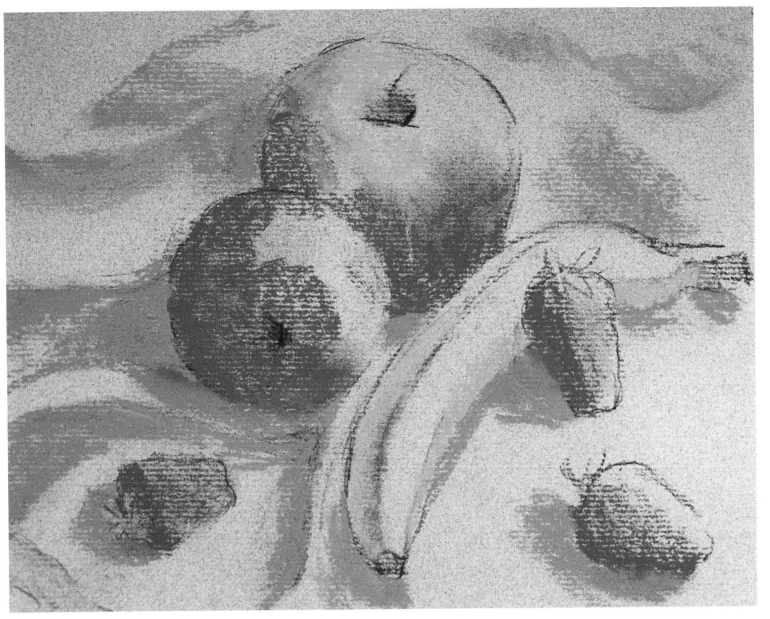

Stroke your darkest red onto the shadow sides of the fruits. Allow a little of the red to drift over the outline of the fruit onto the cloth in places. Use some of the green-yellow on the shadow side of the banana, too – this is rather easier than the apples, because a banana has obvious facets. (You might find it helpful to think of an apple as if it was faceted, too, see page 39.) Stroke blue-grey onto the shadow areas of the cloth.

STEP 3

Use orange-red for the illuminated parts of the fruits, softening the colour into the blue-red here and there with a finger. Then use your brightest yellow with broken strokes on the top facet of the banana, and onto the larger apple. Use simple marks of darker green for the leaves on the strawberries.

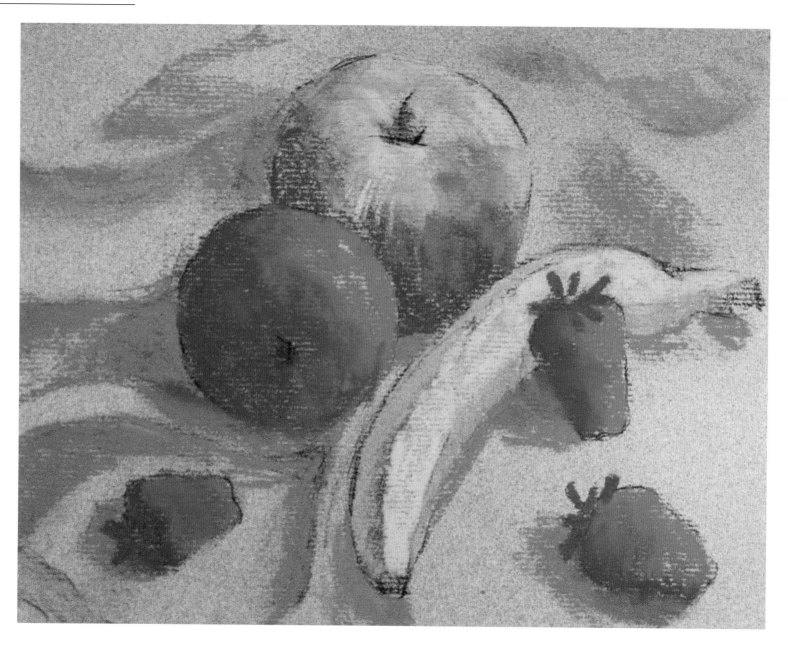

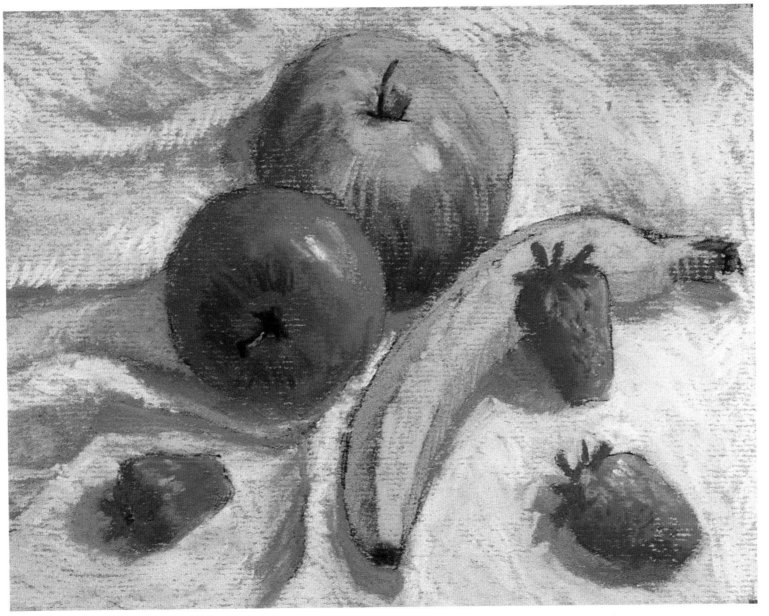

Work on the tablecloth. Begin with the cream, using cross-hatching or feathering, and use white over the top on the raised folds. Dot dark red and bright yellow onto the strawberries to suggest their texture; use charcoal for the apple stalks and the ends of the banana, and a few small strokes of charcoal over the dark red of the front apple to suggest a darker facet. Use a little dark green on the shadow side of the big apple, and some curving strokes of yellow to suggest the pattern on the skin, and the shape of the fruit. Lighten some of the cloth's shadows with a few strokes of lighter blue-grey, and put the highlights on the fruits with tiny strokes of white and cream.

Composing Pictures

If you have followed the lessons so far, you should be feeling fairly confident about pastel techniques, excited about colour, and ready to use your 'visual vocabulary' to produce pictures. However, there is now a very important element to consider, and this is composition – sometimes called, quite simply, design.

The most inspiring subject with glorious colour is no guarantee of a good picture – your picture will fail to excite if the shapes, colours and tones have not been arranged to make a good design. To a certain extent, you can trust your own judgement – if your picture is well composed it will feel 'right'.

Aims

- To consider some of the elements of good design
- To learn why and how to use a viewfinder
- To begin composing pictures with objects and flowers
- To discover how to improve drawing for still life
- To consider backgrounds for still life pictures

Sometimes, however, we need some help with design – the odds are against every subject offering us a perfect composition.

There are no hard and fast rules to stick to, and for now, I will offer a few guidelines to help you avoid some of the more common pitfalls. If you find this aspect of painting interesting, you will enjoy studying books devoted entirely to composition, and will find them fascinating and full of insight; I have found many of them helpful, and encourage you to seek them out in due course. Not only will your sense of design grow and develop as a result, so too will your appreciation of works of art in galleries and exhibitions.

USING A VIEWFINDER

When we think about composing a picture, we have to decide where to place our subject on the paper, how large it should be, and what else to include. Looking through a viewfinder helps immediately – it will isolate the subject from its surroundings, and we can begin to see how the painting might look. You could have several

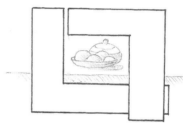

A viewfinder can be made by cutting a window from a piece of card, or by using two L-shaped pieces of card.

viewfinders of different shapes, or you could cut two L-shaped pieces of card to create an adjustable viewfinder, in order to try out different views and shapes of picture.

THE FOCAL POINT

In a ballet, the spotlight highlights the prima ballerina, even if there are other dancers on stage. In a painting you also need a 'prima ballerina' – a main area of interest, sometimes called the focal point.

It often helps to give your painting a title before you begin, which includes a reference to the focal point, such as 'The Blue Jug' or 'Ancient Oak Tree'.

There are certain parts of a rectangle that the eye naturally gravitates to, and a good rule of thumb is to place your focal point in one of these areas. There are four such areas, sometimes called the 'eyes' of the rectangle. My little sketches below show two possible ways to find one of the four 'eyes'.

Draw a line from one corner to another, then draw a line from a third corner so that it intersects the first line at right angles. This is the 'eye' of the rectangle.

Divide a rectangle into thirds. The 'eyes' of the rectangle are where the lines intersect. There are four possible positions.

 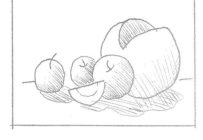

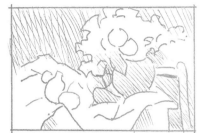 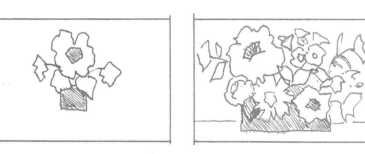

COMPOSITION – SOME 'DOS' AND 'DON'TS'

1

The image on the left shows how equal divisions of the rectangle can be monotonous. Whatever your subject matter, still life or landscape, try not to divide your picture in half – horizontally, vertically or diagonally.

2

Try to create subtle ways to direct the viewer's eye into, and around, the picture. The jug in the left-hand picture leads us right out of the picture. On the right is a sketch of a Cézanne still life – here we move into the picture through lines created by the folds in the fabric and contrasts of tone.

3

Although it is a good idea to avoid putting anything important at the edges of your picture, too much space leaves the subject floating. Always consider the spaces around your subject, as well as the subject itself.

4

The picture on the left has two centres of interest which behave like bookends! Try to emphasise one focal point and subdue any others. Also remember that while similar shapes provide a sense of unity, variety is also needed to avoid monotony.

ARRANGING THE COMPOSITION

A great place to look for still life subjects is the supermarket – the fruit and vegetable counters are usually my first port of call, but recently I spotted a box of colourful little square cakes, and this sparked off my imagination, so I went in search of other simple-shaped, colourful cakes to put with them. I found the jam tarts – lovely little circles of colour – to go with my squares. I chose colours that would work well together – colour harmony, from the red, orange and yellow part of the colour wheel.

However, setting up the cakes and tarts for a still life was not that easy, and I made several different arrangements, making small 'thumbnail' sketches with red conté pencil to work out the composition on paper on a small scale. (We will look more closely at the use of thumbnail sketches on page 79.)

Having studied these examples, do try something similar yourself, changing the arrangement of the objects, your view of them, and the format of your thumbnail sketch until you are happy with the solution.

Right I rather like this horizontal format, the frieze-like appearance of the composition, and the way the third cake links with the background. This is a possible solution.

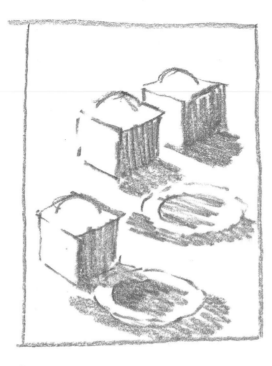

Above It is difficult to know where the focal point of this composition is, although the idea of a vertical format is interesting. Maybe the items at the front should be bigger?

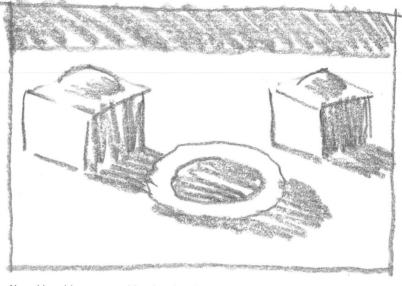

Above Here I have created bookends; a boring composition. *Below* Too much space surrounds the plate – but the arrangement of cakes looks interesting. Let's zoom in with a viewfinder (see opposite page).

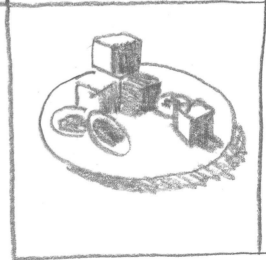

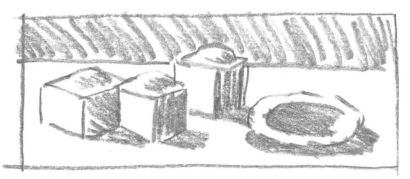

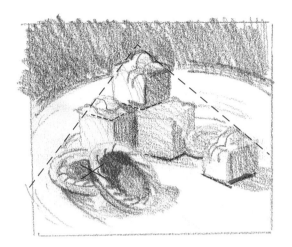

FRENCH FANCIES AND JAM TARTS

This was my final choice. Together, the cakes form
a slightly asymmetrical triangle, which echoes the
triangles formed at the bases of the square cakes.
This actually happened by accident, but it does help
the composition. The half-circle of the plate breaks
up the background nicely too, in an interesting way,
and echoes the tarts. The focal point (the two
tarts) is marked with a cross on the thumbnail
sketch. The tarts are bigger than the other shapes
in the picture, they contain a sharp area of intense
contrast (where the dark red meets the light
colour of the pastry), and their colours are the
strongest and warmest in the picture. The palette
is simple – reds, oranges and yellows, together with
blue-grey and white.

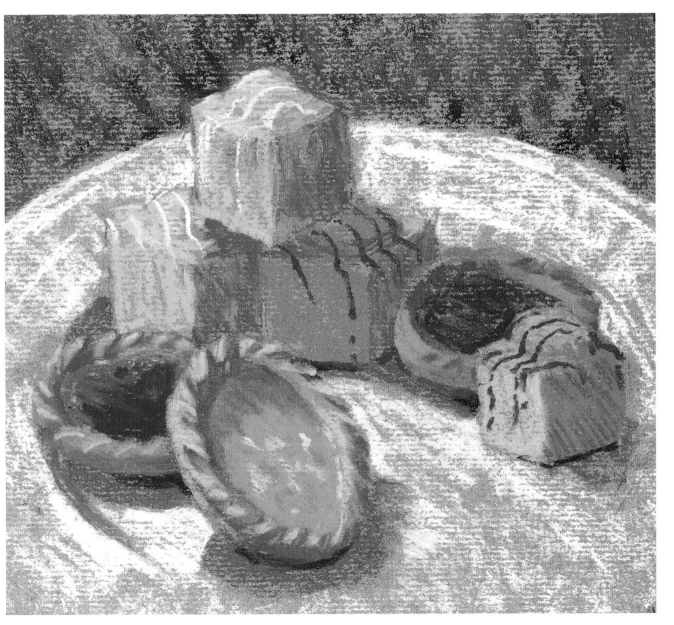

59

SIMPLE FLOWER COMPOSITION

Flowers and pastels go together like peaches and cream! As subjects, flowers provide us with wonderful shapes, vibrant colour and fascinating textures to explore. Also, cut flowers or pot plants will give vitality to a still life.

UNDERSTANDING STRUCTURE

To paint flowers successfully so that they don't look wooden, you need to understand their structure. Making studies of individual flowers in a sketchbook will familiarise you with shapes and forms, and boost your confidence when you come to tackle groups of flowers. You can concentrate on form and structure by working in pencil or charcoal pencil, and do try pastel pencils for colour studies. As you work, observe carefully to see how stalks attach to flower heads, and how leaves join the stems. Check proportions, too. Draw what you really see, not what you think is there! This will give your drawings conviction.

I always recommend that beginners start with simple flowers like daisies, poppies or tulips. These flowers provide plenty of scope for practice of form and colour, but without the confusion of masses of individual petals. Then gradually, as your

confidence grows, you can begin to tackle roses, carnations and peonies – you will soon see that these multi-petalled blooms need to be simplified initially into their main shape, and then perhaps a certain number of petals defined – just enough to describe the character of the flower.

SIMPLIFYING THE SUBJECT

Groups of flowers in a vase or pot are best viewed initially through half-closed eyes. This will enable you to see that while one or two blooms may command attention by virtue of their position, size or colour, others seem to merge together, making it hard to discern individual blooms. This is how you should try to paint them, trying not to define every edge sharply where flowers or petals merge together visually. Also, do look carefully to see how light affects the colours of petals and leaves. For instance, warm light will cause cooler

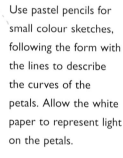

shadows, so a red flower might have an orangey-red side where the light strikes, and a cool, blue-red shadow side.

You could copy my picture, but you may find it more rewarding to set up something similar yourself. Keep the arrangement simple, such as a vase of flowers of the same colour on a plain background, placed centrally in front of you and seen quite close up.

Above and below
Use pastel pencils for small colour sketches, following the form with the lines to describe the curves of the petals. Allow the white paper to represent light on the petals.

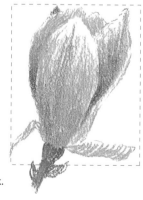

Left Make sketchbook studies in pencil to identify the main shape first. Always check proportions as you work.

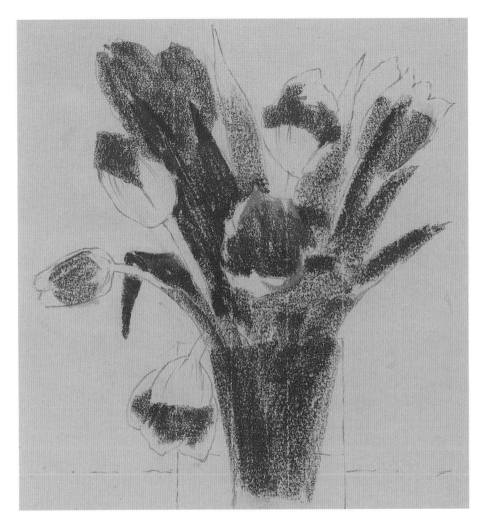

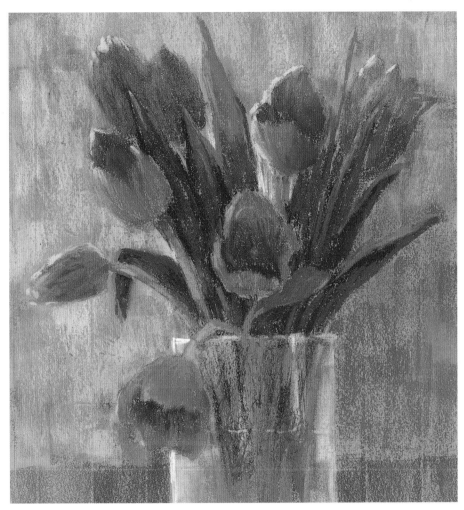

STEP 1

Start by drawing the shapes of the flowers with pastel pencil or charcoal (I used a red-brown pastel pencil). Using a limited number of pastels (here I used white, and light, medium and dark tones of red and green), begin with your darkest tones, using loose side strokes. Don't worry about keeping within your drawn lines – the flowers may droop as you work anyway!

STEP 2

Fix the dark tones before building up the image with medium tones, and lastly the palest colours to suggest the light touching the petals and leaves. Keep the background simple. I used broken colour, using a very light touch to drift the colours over each other. I finally added red at the bottom of the picture to echo the flowers.

THE STILL LIFE

One of the best things about tackling a still life is that you can take your time with it, particularly if you choose objects that won't perish. This means that you can think carefully about the tones and colours, the composition and the techniques you want to use. You can choose your objects and arrange them to suit yourself, so you can begin with fairly simple compositions and gradually work towards more complicated arrangements.

There are three main aspects to consider when setting up a still life: the objects, the composition and the lighting.

THE OBJECTS
Lots of different shapes and many different colours can be too busy and confusing. Similar shapes and colours will give unity to the painting, and you can introduce a little variety with contrasting sizes and perhaps a touch of complementary colour.

COMPOSITION
Always look at your arrangement through a viewfinder to consider the composition. Look critically at the spaces around the still life, as well as the objects. Too much space will be very difficult to deal with, and you can solve the problem by the way you place your still life within the rectangle. I find that one or two quick thumbnail sketches (see page 58) will help to decide on a happy composition.

LIGHTING
Make sure the lighting is directional and uncomplicated – one light source will give you straightforward areas of light and shade with simple shadows. Back-lighting is exciting to try – with the light behind your subject, it gives a delicious rim of light along the tops of objects, and will simplify the tones because it silhouettes the objects.

DRAWING SYMMETRICAL FORMS

Natural forms such as vegetables, fruits and flowers have organic shapes, and you can be forgiven for drawing them a little incorrectly, because if they are not exact, no one will know! However, if you intend to include man-made objects such as bowls, plates, vases and jugs, you have to be able to draw them correctly.

To check the shape of a vase or bowl, draw the shape, then take a piece of tracing paper and trace the left-hand half of the object to a central vertical line. Then reverse the tracing paper, and place it over the right-hand half of the object to check the outline.

A common mistake is to make points at the corners of an ellipse, but even a shallow ellipse will have curved corners. An ellipse will fit into a rectangle, and to check your drawing you can divide the oval shape into four to see if you have created a symmetrical shape. Always check proportions carefully.

Another very common error is to draw the base of a vase or bowl with a straight line because it is sitting on a flat surface. However, when we look down on an object, if the lip is curved, the base must be slightly more curved. The central line helps to check symmetry.

BLUE JARS AND MARBLES

Because the bowl and vase play such a large part in this picture, they had to be very carefully drawn. Notice how the bases are all curved, even though the objects are sitting on a flat tabletop. One source of light was used, from the left, which adds far more drama to the picture than an overall flat light from the front. I deliberately chose colours which would work well together – the green, blue and purple range of harmonious colours from the colour wheel – and I selected a warm umber paper, to add a touch of warmth to contrast with all the cool pastel colours.

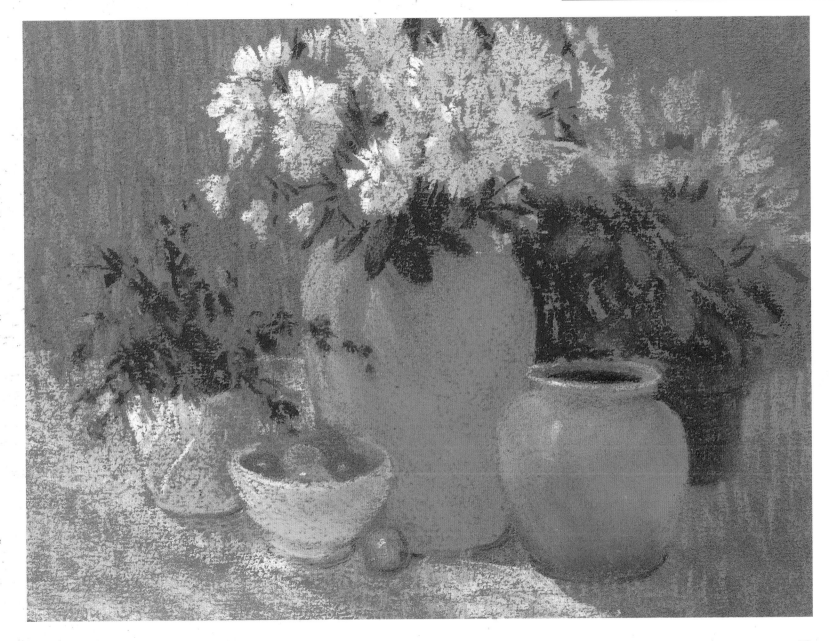

BACKGROUNDS FOR STILL LIFE PAINTINGS

'What do I do with all that background?' is a common cry from a beginner who has simply placed the subject in the middle of the paper and left the background to sort itself out later! It may help to think of the picture as a jigsaw puzzle, and to consider all the objects in the still life and the background shapes around them as important pieces of the puzzle.

There are many ways of thinking about backgrounds, and we will look at some of them on these pages. You may find it useful to study the still life paintings of an artist such as Cézanne, Van Gogh or Matisse, to discover some of the different approaches that they used.

EDGES AND VIEWPOINT

When looking at the subject, many people neglect to take the edges of the rectangle of the picture into account, almost as if they don't exist! Yet these edges frame the picture and force us to look at the background as part of the subject, making us aware of what might be an uninteresting sea of flat colour, or of the large shape of an object which dwarfs the still life.

This is why looking through a viewfinder (see page 56) is so important, as it provides

us with edges around the still life. Holding the viewfinder close to your eye will allow more of the background to show, while holding it further away will allow the objects to fill the rectangle and eliminate much of the background. This latter option is one way of solving the problem of backgrounds! Another option is to change your viewpoint and look down on your still life. In this way, the tabletop or surface becomes the background.

COMPOSING THE BACKGROUND

Instead of making the most of an existing background, you may enjoy selecting one deliberately. You could use a window, a cupboard, or a mirror, for instance, if you like the idea of a challenge! For additional colour and pattern, set up your still life against a patterned wall, or hang some fabric or coloured paper behind it. Gift-wrapping paper can provide you with inexpensive, colourful patterned backgrounds. Alternatively, place your objects near to a plain wall and direct a strong light onto them. This will throw shadows onto the wall, giving interesting shapes in the background.

If you like the idea of setting your still life within a simple coloured background, it is probably best to choose a basic colour which either harmonises or contrasts with

Here, the view clearly looks down on the subject; the background is restricted to the surface that the objects are set up on.

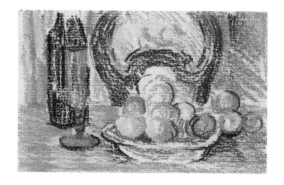

Cézanne has used a curved chair back in the composition, which echoes the shapes of the fruits; he also took colours from the still life and tabletop into the background.

The background of this still life consists of abstract random stripes, the colours echoing those used in the rest of the picture.

These examples are taken from three paintings by the French Impressionist painter, Cézanne.

the colours of the still life. Using broken colour techniques will prevent a plain background from being boring. You need to think about ways of linking the background to your still life – echoing some of the colours used elsewhere in the picture works well. Set up the still life objects against a plain background so it is not distracting.

RED APPLES

I couldn't resist these gorgeous red apples! I stood to paint, looking down on the still life, and used a spotlight to give strong directional light and interesting shadows. The focal point of the picture is the largest red apple, which is sitting on one of the 'eyes' of the rectangle (see page 57). The background is simply the teacloth – a simple solution to the problem of background. The red stripes harmonise with the red apples, providing a good visual link, and the diagonal pattern adds interest and variety.

I began with the darkest reds on the apples, using broad side strokes, then I added the medium tones of red to establish the fullness of the apples. I used a finger to blend some of these medium and dark tones together because the texture of the paper was showing through my side strokes, making the apples look slightly rough, and I wanted them to look shiny. The patterns on the skin and the highlights were painted last.

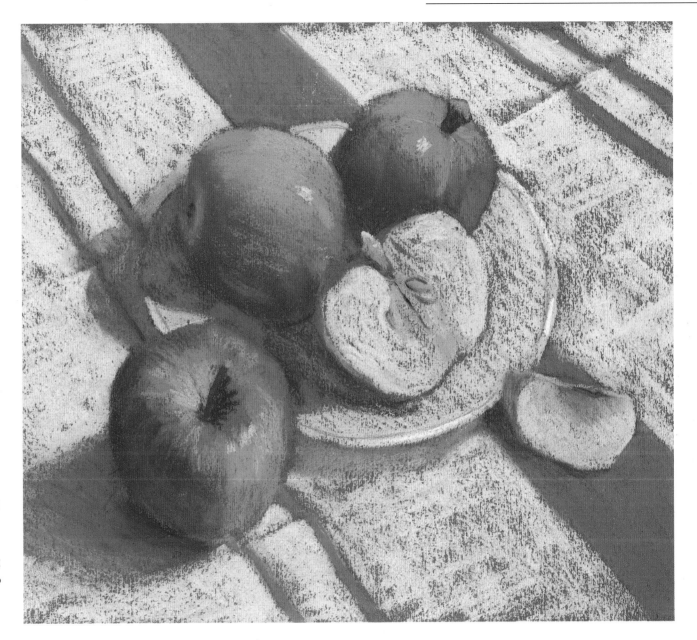

PANSIES IN A DECORATED POT

For this simple still life subject I worked at the same size as the main steps in this demonstration, so if you want to trace my outlines, you can do so. However, do study the drawing on this page which underlies the pastel work; I have left all the construction lines on it to show you my thought processes.

It was important to draw the little pot correctly, and I measured it carefully. If you measure my drawing you will discover, as I did, that the height of the pot is exactly the same as its width at its widest part – so I could have drawn a square, and fitted the pot into the square. I did draw the centre line with a row of dots to help to get the shape and proportions right; also I held my pencil up to see the angles between the bottom of the pot and the pansies, and I dotted in these lines to plot the positions of the pansies. Drawing in dotted lines like this to position things carefully is a really good idea before launching into colour – especially if you want your drawing to be fairly accurate! I used black conté pencil for crisp lines, but did not rub it out – pastel will cover any charcoal, or conté quite easily. The flowers all face me – which is perhaps a little pedestrian, but together they form an arc which echoes the shape of

the pot – which, incidentally, does have a straight, flat base, unlike its neck, which is an ellipse.

I used the complementary colour pair, purple and yellow, for this image, with purple being the dominant partner, plus touches of blue. Eight main colours make up the palette, plus tiny touches of three other colours for the flower centres and stalks.

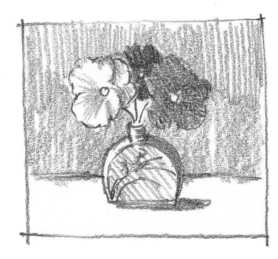

Above I zoomed in quite close in my thumbnail sketch as it is important to control the space around a single vase of flowers like this.

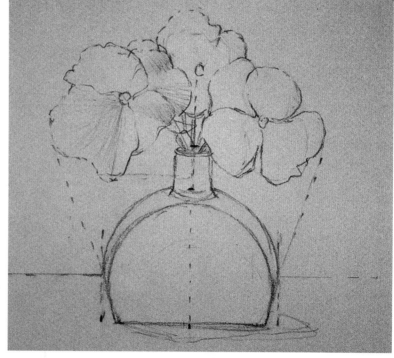

STEP I
Use charcoal for the initial drawing. Correct any mistakes by dusting the lines off with a tissue and redrawing.

STEP 2

Begin by painting the purple pansies, one of which
is slightly lighter in tone than the other. Use linear
strokes of dark purple for the back flower, and
medium purple for the flower on the right. Build up
your strokes until there is hardly any paper to be
seen through the marks. You don't need to press
too hard – just keep working until you have a
dense area of colour. As the pot is a slightly larger
shape, you might be able to use side strokes of pale
purple-grey if you have broken your pastel stick
into smaller pieces. Otherwise, use linear strokes
as for the flowers, building up a fairly solid area of
pastel. Use the same colour for the shadow on the
tabletop. Then take all three pastels used so far,
and with a very light touch, use short side strokes
of pastel in the background, working quite freely as
I have done.

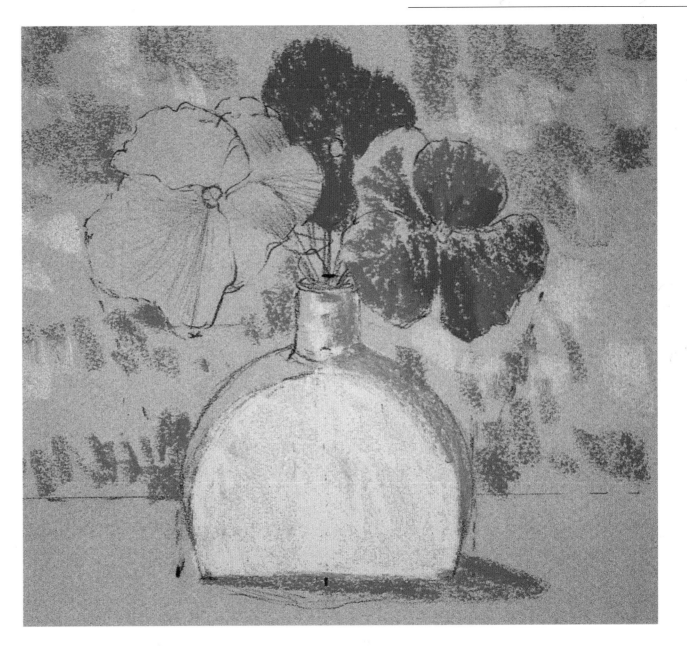

STEP 3

Using linear strokes as before, following the shapes of the petals, paint the shadowy parts of the pale yellow flower using both the light purple-grey and the greeny-yellow together. It may be best to use the purple-grey first, and the green-yellow over the top, which gives a lovely effect. It is important to find the right colour for shadows on yellow – if you simply used grey, the flower would look dirty!

Put in the green stalks for the flowers and the darker yellow for the centres. Finally, use vertical side strokes of yellowy-green for the table top.

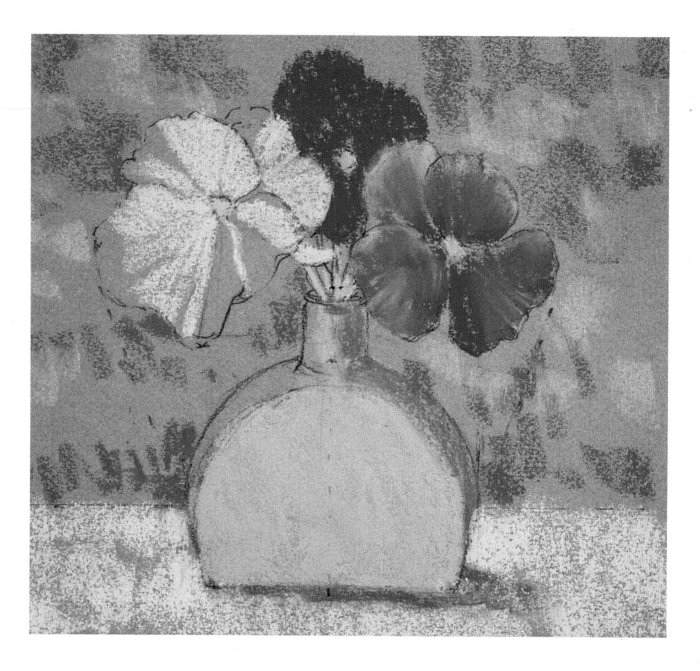

STEP 4

Having the patience to build up a picture slowly and carefully, working from dark to light, now pays dividends, because I feel sure that like me, you will really enjoy this final step, watching the picture magically come to life. Use small linear strokes of palest yellow for the bright parts of the light flower. Stroke some of this same pale yellow over the tabletop. Block in the bright side of the pot with white, and gently layer a little white, with gentle side strokes, over the left-hand side of the tabletop. Put a few strokes of black onto the rear pansy, which has a dark surround to its centre. Using a feathering technique – lots of small vertical strokes – complete the background, using medium blue and bright blue together. Define the right-hand flower with a few small linear touches of medium blue and purple. Finally, add the decoration on the pot, using purple and tiny touches of bright blue – but keep your touch light and the marks loose!

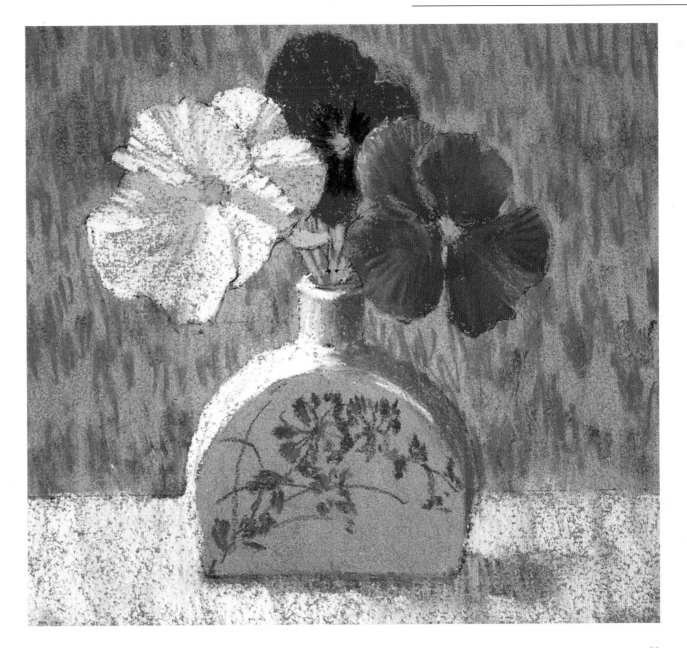

Landscape Painting

Landscape painting is, arguably, the ultimate challenge for the painter. Not because it is any more difficult than any other subject, but because of a major hurdle – that of working out of doors. You have to expect to encounter problems with the weather – rain and wind are horrid for the pastel painter, and even sunshine can be hazardous! I have often selected a shady spot in which to sit, only to discover after a while that the sun has moved around and one arm is slowly cooking! I am always a source of great interest to vampire-like mosquitoes; if I stand for ages my back hurts, and if I sit for ages my bottom hurts! However, the only way to learn to capture the beauty of the landscape

is to ignore any discomfort, and this isn't too hard to do once you are fired with the challenging business of getting to grips with composition, tone and colour on the spot.

Of course, you could easily work from photographs in the comfort of your home, but a photograph is a poor second best because tones and colours will be distorted; the atmosphere of the scene will often be lost and you would need a magnifying glass to make out the textures and details that are seen clearly by the naked eye.

SELECT, SIMPLIFY AND PLAN

You will soon discover when you work on the spot that you have to work with urgency before the weather or the light changes your scene, and as a result your paintings will have a freshness which is difficult to achieve in any other way. You have to learn to select: not everything in a scene is desirable; and to simplify: there is no time to paint every leaf or blade of grass, so you have to choose techniques to give the illusion of nature's glories. To make the best use of limited time, and to capture

fleeting effects of light and weather, it helps to plan your picture, using a viewfinder to select a composition, then producing one or two alternative tonal thumbnail sketches before launching into colour. However, let's not run before we can walk. We will begin by taking a gentle artistic stroll through the landscape, studying some of the features along the way to see how we might simplify them, and what possible techniques to use. This will give you confidence when using these elements in a composition.

A LANDSCAPE SKETCHBOOK

It is always good practice to build up an arsenal of ideas and experience by experimenting with the painting of individual landscape elements, without the pressure of having to produce a complete picture. I suggest that you begin your own special landscape sketchbook, to keep for all your thumbnail sketches (which we will look at shortly on page 79) and also for lots of small full-colour vignettes – little corners of the landscape – like those on the next few pages.

Aims

- To consider ways of simplifying landscape features
- To learn how to recognise the variety of greens in the landscape
- To learn how to create the illusion of space
- To develop an understanding of good composition for landscape painting

Below Short linear strokes suggest grasses and rocks.

Below Side strokes of blue imply sky behind linear marks for branches and dots for foliage.

Below Dots and dashes give the illusion of grasses and poppies beyond.

Right Small pieces of brown and orange pastel were used on their sides for the treetops, and blended to suggest fullness. I used the points of the pastels for the tree trunks.

Left I swept a blue-grey pastel across the page, and softened it with a finger. Then I dotted the same colour on to suggest bushes. The green and yellow for the distant fields were layered over the top of the grey, and finally I suggested the distance with tiny dots of blue.

Right A cluster of bluebells inspired this little vignette – broken colours of blue and purple give the illusion of masses of blooms.

Right I swept the side of a brown pastel across the page to depict the furrowed field, and then twisted a green pastel, on its side, for the hill behind. Tiny linear marks hint at fence posts.

Above right Broken colour, using pink and several greens, gives the impression of a mossy bank. Short strokes of pink and blue-grey were used for the track and the shadow, and finally the post and curving lines were painted with the point of the pastel.

TEXTURES IN THE LANDSCAPE

What we are trying to do when recreating the textures we see in nature, is to search out the essential quality of the subject, and then find a convincing way of expressing that quality with pastel. This may not be of primary concern to you when you attempt a distant landscape view, but many landscape painters prefer to deal with the subtleties of form, colour and texture to be found in a small corner of the landscape. There are lots of textures out there, both natural and man-made. However, do remember that you are a painter, not a camera. If you try to record every tiny detail of texture that you can see, you run the risk of overdoing things and the result may look strangely unnatural. This is because when we admire a scene, we take it in as a whole. We see the overall texture of a rough stone wall; we don't really see every individual stone. If you can manage to find a kind of shorthand to describe grass, foliage, rough bark, brick wall or mossy bank, you will find that the viewer will understand and enjoy the experience of looking at your picture and using his or her imagination a little.

Brick and stone walls always seem to cause huge problems for beginners because they feel obliged to paint every brick or stone. For both these walls I used broken colour first, and added the linear marks for the spaces between the stones last. However, I have not defined every single stone — there are just enough lines to tell the story.

In each of these little examples of texture, I added the small details last over broad colour areas. To begin with it helps to squint so as to eliminate detail. Be particularly careful of shadows on grass — they have soft edges.

Working on a green paper gives unity, but no contrast to the scene, so the greens look dull.

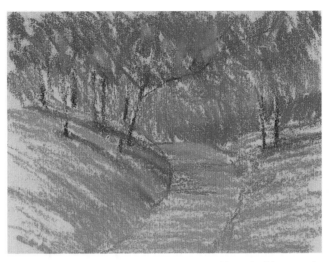

The bright pink paper makes the greens sparkle and adds warmth and light to the scene.

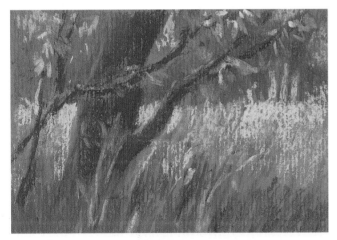

There are blues in the shadow areas, and bright yellow and orange in the middle distance, where sunlight makes the ground glow. These extra colours add interest and excitement to an essentially green woodland scene.

These are just a few of the many greens available in pastels, including some subtle grey-greens and ochres.

SELECTING AND USING GREENS

The colour of danger is universally accepted as red, but for the landscape painter it should definitely be green! Many of the boxed sets of pastels for landscape painting contain a fairly limited range of greens, and often these are the brighter viridians. If you use these vivid artificial greens to paint the soft landscape colours to be found in nature, your paintings will look garish and unnatural.

There is an enormous variety of different greens in nature, and to capture them we need a good range from light to dark, including olive-greens, blue-greens and grey-greens. Most importantly though, we need to look carefully at the light in a scene: warm light will give us yellow- and olive-greens; shadows will be cooler and more blue-green. Shiny surfaces may reflect nearby colours, and you may even spot oranges, pinks, blues and browns amongst a mass of green foliage.

Observation is the key, and if you don't have quite the right green in your set, don't worry – you can create optical mixes by overlaying colours, which will look vibrant and exciting. Using a contrasting paper, such as a warm umber or even a pink, will give warmth and sparkle to cool green areas.

FOREGROUNDS

Most landscape scenes have a foreground, middle distance and distance. As artists, our job is to encourage the viewer's eye to move easily from the foreground to the distance, yet I have often seen students place a wall, a fence, or a row of grasses across the bottom of the picture, which effectively prevents the viewer from 'walking into' the picture.

SCALE AND TEXTURE

Recession of space will be emphasised if the marks you use in the foreground are larger than those used for more distant areas. However, don't fall into the trap of making the foreground highly detailed if the rest of the picture is more of a general impression, or it will look like two pictures!

Colours will be brighter, and tones stronger in the foreground. If your foreground is a large area of fairly uniform colour without much texture, it will help to vary the colours, or to look for shadows, or undulations in the land to add interest and bring the area forward. Whether the foreground is a large or small area of your picture, always try to integrate it with the rest of the image, perhaps by repeating colours or shapes in other areas, and try to lead the eye into the picture.

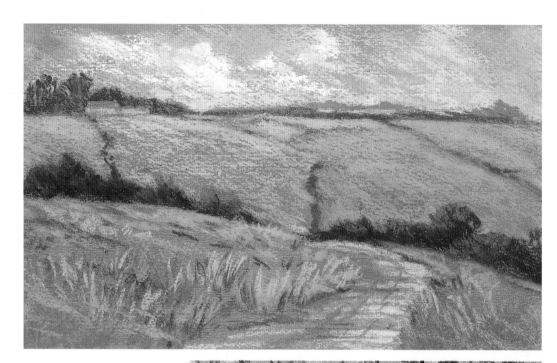

Right This simple landscape is made up of a series of interlocking shapes, linked visually by repeating colours. The texture in the foreground, which is fairly simply stated to suggest long grasses, commands attention first, and then we move back into the landscape via the path and the hedges between the fields.

Right The warm colours, the crisp descriptive marks for the ferns under the main tree and the strong tones bring the foreground forward. Although the foreground is busy and prominent, we are led back into the picture by a suggestion of a path, and distant marks are smaller, edges are softer and colours cooler.

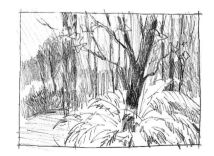

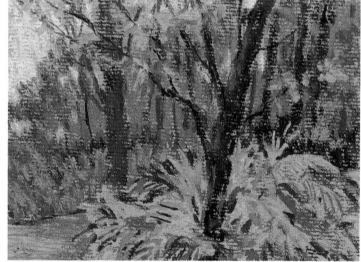

TREES

There is a simple way to avoid painting trees that lack conviction: look at trees themselves! This may sound like stating the obvious, but I know from experience that to many students a tree is such a familiar object that they think they know what it looks like, and they generalise. This leads to a stereotype of a tree, looking like either a cardboard cut-out or a green lollipop.

SILHOUETTE AND FORM

Each type of tree has its own characteristic silhouette and its own specific growth pattern. Remember that trees are three-dimensional, not flat, so branches not only spread from side to side, but they also grow towards you and away from you. Even in summer when foliage is lush, there will be gaps through which you can see sky and branches – gaps for birds to fly through! The edge of even the thickest of trees is often quite filigree. The light helps to reveal form – clumps of foliage will usually be lighter on top, with darker shadows below. Study tree trunks carefully – they are seldom just brown, and their texture may catch the light to reveal the roundness of their form – your marks could follow their contours.

In general terms, it is sensible to begin the painting of a tree with the darkest tones, adding the lighter tones gradually to describe the form – and perhaps some suggestion of the type of foliage, without overdoing it. A willow tree, for example, will require a very different treatment from an oak tree. Groups of trees, particularly those in the middle distance and distance, will unite to form a single shape, but there may be some variations in tone and colour, so look hard, then look again! If you have a garden or park nearby, practise sketching trees as I have done, using either pastel pencils or pastels, to add to your store of knowledge and experience.

Form is revealed by the light on the foliage and the contours of the tree trunk on the right.

The silhouette was studied and defined with dots; then foliage was added with small strokes of pastel, working from dark to light.

Light

CREATING THE ILLUSION OF SPACE

Creating space in your landscape pictures is fundamental to the success of the image. Ideally the viewer should feel able to 'hike' through your scene, from the foreground to the distance beyond. To a certain extent, simply painting exactly what you see in front of you should do the trick, but so often beginners draw and paint what they think is there, rather than what they see.

A common mistake is to paint a distant field much larger than the size you can actually see because you know that it is a big field, but this will destroy the sense of distance. It is important to measure proportions as you work.

Colour plays an important part too; the feeling of depth in your picture can be emphasised by the way that colours fade away into the distance. Trees in the distance are no less green than those in the foreground,

and the distant hills are not actually blue, yet this is what we see. This is because atmospheric haze – vapour and dust particles – interferes with our vision, lessening the contrasts, tones and colours towards the horizon. The distance also 'softens' edges.

Some of the devices for creating a sense of space are shown in the small sketches on this page. It might be helpful to make a note of the various approaches in the back of your sketchbook to refer to.

To take measurements, hold your pencil at arm's length and lock your elbow. The top of the pencil should touch the top of the object and your thumb should touch the bottom of the object. Use this measurement to check the object's height against its width, and its size against other elements in the scene.

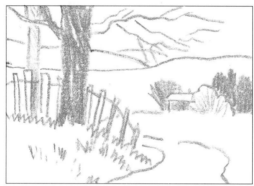

Top far left Exaggerating overlapping forms creates space.

Top left Change of scale helps the illusion of recession.

Bottom far left Depth is emphasised when texture is evident in the foreground, and softer and less distinct as it recedes.

Bottom left Linear perspective – though not always as obvious as this – helps to take the eye back. (We will look at this again on page 108.)

**PROVENÇAL
LANDSCAPE**

I used lots of different ways to create depth in this landscape. As an exercise, see how many elements of 'creating space' you can identify in this painting. Analysing a picture instead of simply looking at it, is always an excellent learning tool.

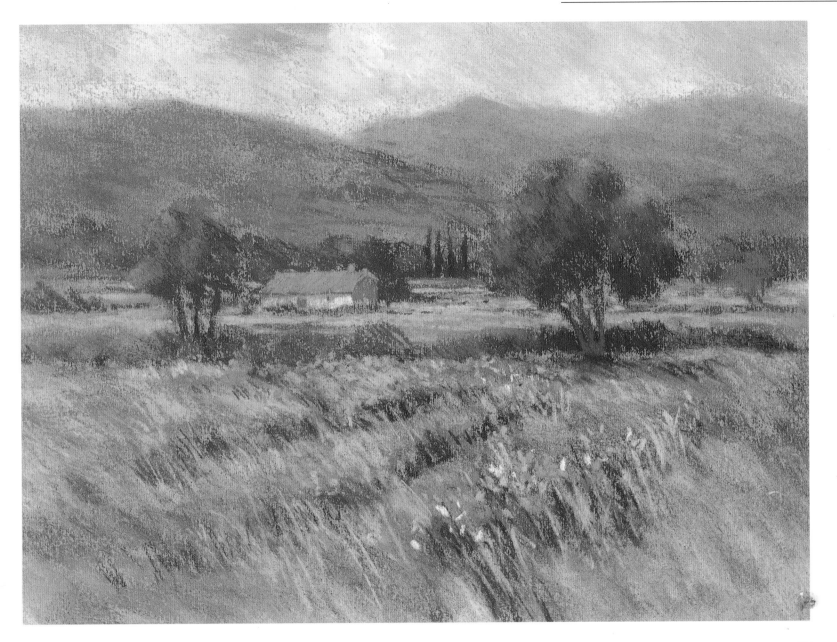

LANDSCAPE COMPOSITION

We have spent a little time looking at how to tackle some of the individual parts of a landscape scene; now it is time to put it all together. If you work out of doors, you will realise, quite obviously, that the landscape is all around you, and that it can be difficult to decide quite what to paint, let alone how to paint it. Even if you spot a scene which appeals to you – a poppy field, for instance, or some stunning autumn trees – you still have to design the picture, so that the scene sits comfortably inside a rectangle, and the shapes, tones and colours all work well together.

ANALYSING THE SCENE

If you look at your scene through a viewfinder (see page 56), you will immediately start to compose a picture as the viewfinder will isolate a part of it for you. Then you can analyse the scene. What is your focal point? Where should you place it? Can you find ways to lead the eye into the scene, towards the focal point? What is happening with the light? Does the scene offer an interesting arrangement of light and dark areas? Is the view interesting, or

rather pedestrian? How could you improve it to strengthen the image? What would you like to change, or leave out? This is the sort of question an artist needs to ask, rather than simply slavishly copying what is there.

Also, make sure you really like your subject; if you are rather bored by your scene, you will probably produce a boring picture! Make a note of your first, excited impressions by writing yourself a little sentence in your sketchbook: 'brilliant red poppies, a sea of green and red', or even create a title for your picture. This will help you to hold on to your focus as you work, which can sometimes get lost along the way while you struggle with composition, tone and colour. All good paintings have a well-considered, underlying structure – the abstract elements of shape, rhythm and linear pattern – and if you manage to think about these things and include them, even just a little to begin with, your picture will benefit enormously. You don't have to feel trapped by your initial ideas, however; you can change your mind and your focus at any time if a better idea occurs to you. Inspiration has a way of creeping up on you sometimes!

My little sketches here show some visual reminders of compositional ideas.

Right Horizontal (or vertical) elements are often predominant in a landscape. Do look for some opposing elements to break any monotony, however.

Left Find ways to lead the eye into the picture. If the road or stream bends the wrong way, change it!

Right Focal points, like this house, are best placed off-centre. Divide the rectangle into thirds in your mind, and place the focal point where the lines would intersect (see page 57).

Left Try to see landscape elements as flat shapes, and find ways to echo those shapes for unity and rhythm.

THUMBNAIL SKETCHES

I don't know why, but many students resist the idea of doing a thumbnail sketch. Perhaps it is because they are so excited by their subject that they cannot wait to get cracking with colour, or perhaps they worry about the time it will take, and that the light and the scene will change before they get started. However, I assure you that the five minutes or so you spend on a thumbnail sketch may save you a great deal of time later.

The placing of the elements of the scene is the first step. Consider the shapes, rhythms and lead-ins as you sketch the outlines. However, the most useful aspect of the thumbnail sketch, in my opinion, is the definition of the light and dark areas of the scene. I emphasise the word 'areas', because I want you to try to simplify every scene into its main areas of dark, medium and light. This may require a major shift of thinking, as most beginners think about the objects in a scene, not the areas of tone. Squinting will help enormously, as colours and objects will take second place to tone.

When you compose your picture, look for the opportunity to use counterchange (the placing of light against dark, and dark against light), a technique that produces strong tonal contrasts which can be used to attract the eye in a painting. Counterchange could be used effectively to help draw attention to the focal point of a composition, for instance.

Keep your thumbnail sketches small and simple, without detail. Doing more than one thumbnail sketch of a scene, altering the view or format, will help you to make decisions about the best composition. It is best to work from life, but if you can't, use a photograph, or part of a photograph, to practise some thumbnail sketches as shown here.

Tip

Always make sure that your thumbnail sketch and your picture have the same proportions (see page 109). This may sound obvious, but I have seen many students trying to make a square thumbnail sketch fit into a rectangular format – with much frustration!

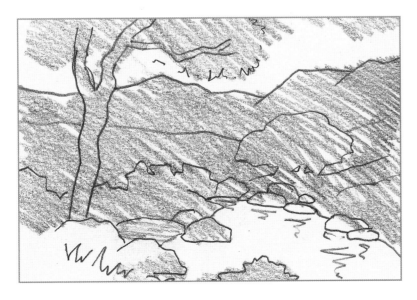

Right Start by dividing a linear drawing into two main areas of light and dark tone, using a 4B pencil to scribble over the drawing, leaving the lightest areas.

Far right Then add darker tones, and lift off some parts (such as the hard edges of the hills) with a putty rubber.

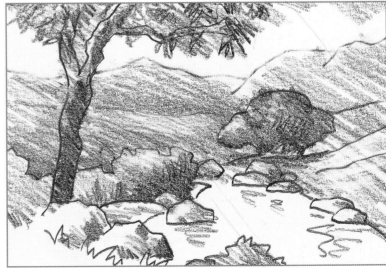

DISTANT LAKE

Although the finished image of this landscape painting looks a little complex, you will see from the stages that it is, in fact, quite a simple process. There is a good sense of recession in the image, which is what I want you to practise. Whether you choose your own subject or copy this image, try to be aware as you work of the devices that I have used to create a feeling of space, and introduce them into your own painting.

Depth is emphasised by the change of scale of both the marks used, and the objects that they represent, implying a great deal of space in the picture – the viewer walks along the path, and then down an unseen hill towards the middle distance. The curve of the path and river then take us back into the picture. Overlap has been used to emphasise the relative position of elements of the composition. Aerial perspective has been brought in through the use of warm colours for the foreground and much cooler colours in the distance where edges have also been softened.

I have used a limited palette of greens and blues on an apricot-coloured piece of pastel paper, which gives the image warmth where it shows through the pastel strokes.

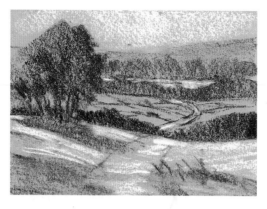

Begin by doing a small thumbnail tonal sketch on coloured paper – any colour will do. Use charcoal, and white pastel for the lightest areas. The object of the exercise is to clearly define a foreground, middle distance and far distance.

STEP 1

On a sandy-coloured pastel paper, sketch in the main shapes of the image with charcoal. Use the side of the charcoal to block in the darkest parts of the picture.

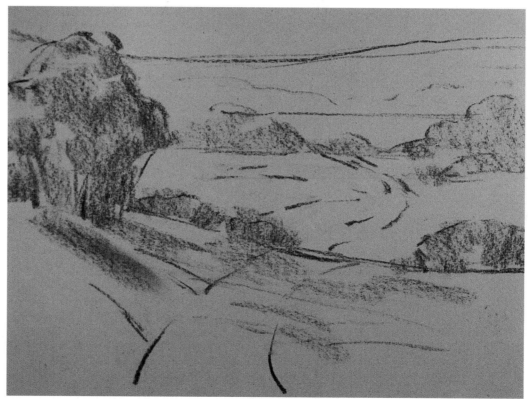

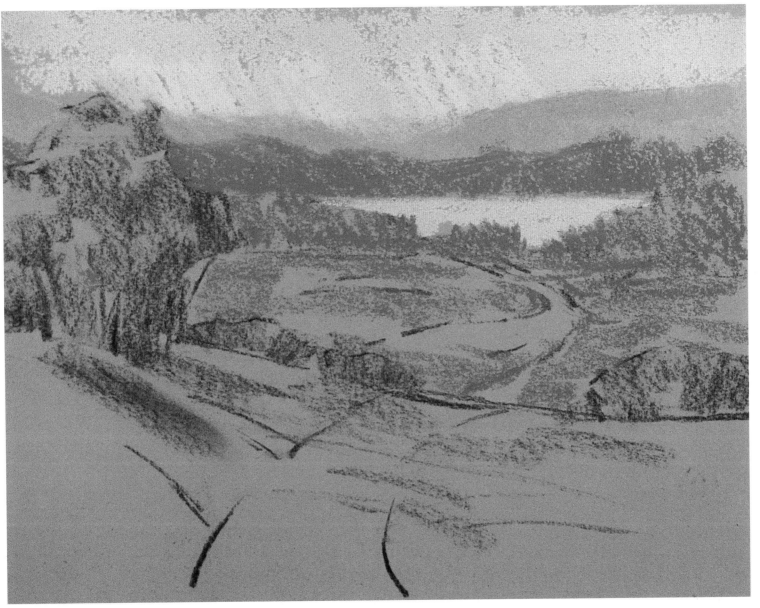

STEP 2

Block in the sky with side strokes of palest blue, and echo the sky colours in the distant lake. Use pale grey for the furthest hills, softening the skyline by bringing a little of the pale blue down over the edge of the hills in places. This will add to the feeling of recession. Use side strokes of blue-grey for the landscape beyond the lake, and using the same pastel, use broken strokes in the middle distance.

STEP 3

Use dots and dashes of blue-green to suggest the forms of trees and hedges in the middle distance. Then use your darkest green for the foreground trees and shadows on the ground. Keep the darkest parts of the trees on the right, to indicate light falling on the trees from the left.

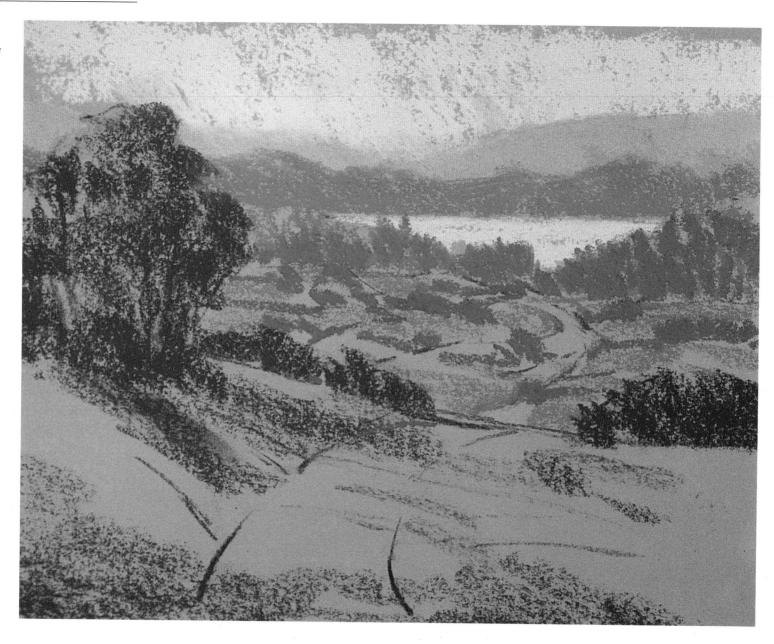

STEP 4

With small strokes of medium and light green, work on the foreground trees, reserving the lighter green for the light-struck sides of the trees. Boldly sweep side strokes of the same light green across the foreground with large marks, and then break up the foreground a little with touches of medium green to suggest grasses. Put small strokes of light green between the tree trunks, and into the middle distance to suggest fields – recession will be implied by the change of scale in the marks. Use a broken line of light blue to suggest the river, which helps to take the eye back into the picture, and continues the curve of the subtle path in the foreground. Lastly, put a few touches of cream onto this path, and make sure that the foreground trees have filigree edges by adding minute touches of dark green here and there.

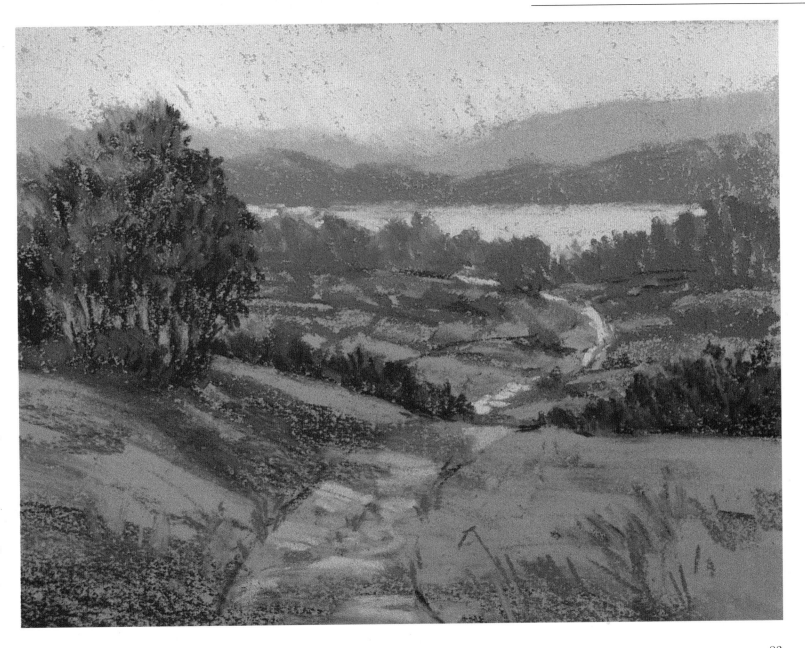

POPPY FIELD

This landscape painting concentrates on
an image which is largely composed of
foreground. The approach is very
impressionistic – the flowers are suggested,
rather than painted literally. If you are
copying this example, do so freely – it will
not matter at all if your image differs from
mine – in fact, you might even produce
something rather better! There are some
important things to notice, however.

Most of the strokes for the grasses and
flowers bend towards the house behind the
hedge. (It is always a good idea to find ways
of subtly directing the viewer's eye to a focal
point – this adds to the strength of the
composition.) The poppies are massed
together in places, producing larger shapes,
which is really important if you want to
avoid the impression of a polka-dotted field!
To create a sense of recession, the poppies
are large in the foreground, and become
smaller towards the back of the field.

If you decide to copy this image, or to
produce something similar, I suggest you
scale up the size a little, which will give you
more chance to work in a lively, loose way.
You certainly do not need to trace my
drawing as the composition is so simple.
My original is 23 x 28cm (9 x 11in), but it
would be fun to work even larger than this.

STEP 1

After producing a small thumbnail sketch (left), plot
the main parts of the image with charcoal on a
pearl-grey sheet of pastel paper. (This image will
also work well on a raw umber-coloured paper.)

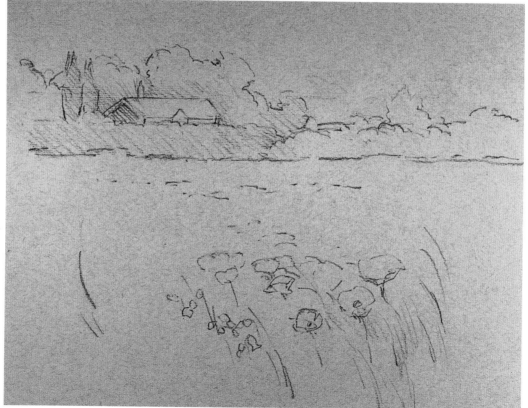

STEP 2

Using small linear strokes of blue, paint in some sky. Then with your two darkest greens for the trees and the bottom part of the hedge, paint the foliage with tiny strokes, changing direction now and then so that some strokes overlap others. Using the same two greens, flick in long strokes in the foreground to suggest tall grasses and flower stems, and indicate smaller clumps of grasses in the middle distance.

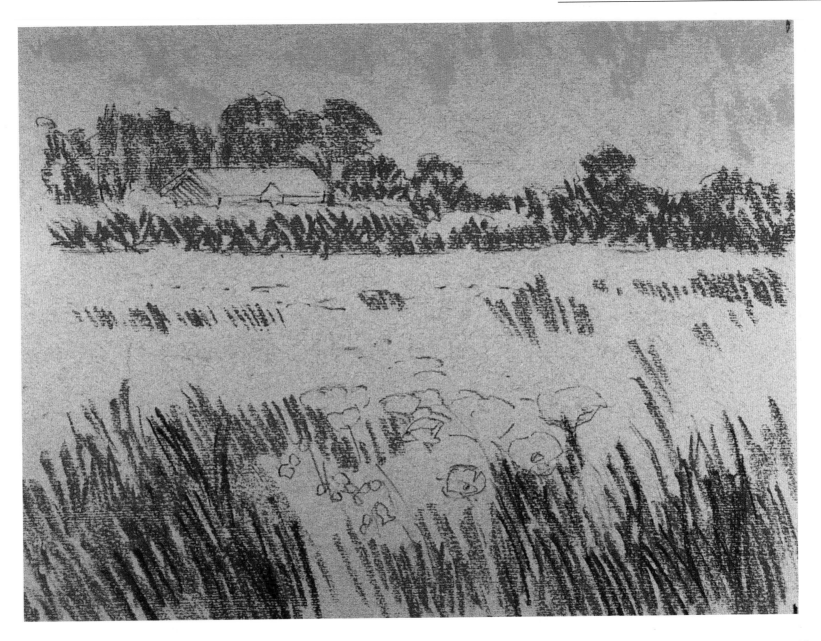

STEP 3

Block in the roof of
the house with bright
red, and use the pale
blue for the triangle-
shaped fascia boards.
Use dots of dark blue
for the conifer trees,
and cross-hatch the
same dark blue with a
little red for the
darker, front-facing
eaves of the house.
Suggest the light
striking the top of the
hedge and clumps of
foliage in the trees
with a lighter green,
and bring the same
green down into the
middle distance
together with tiny
strokes of yellow. Start
on the poppies, using
the two darkest reds,
joining up the dots to
produce clumps here
and there.

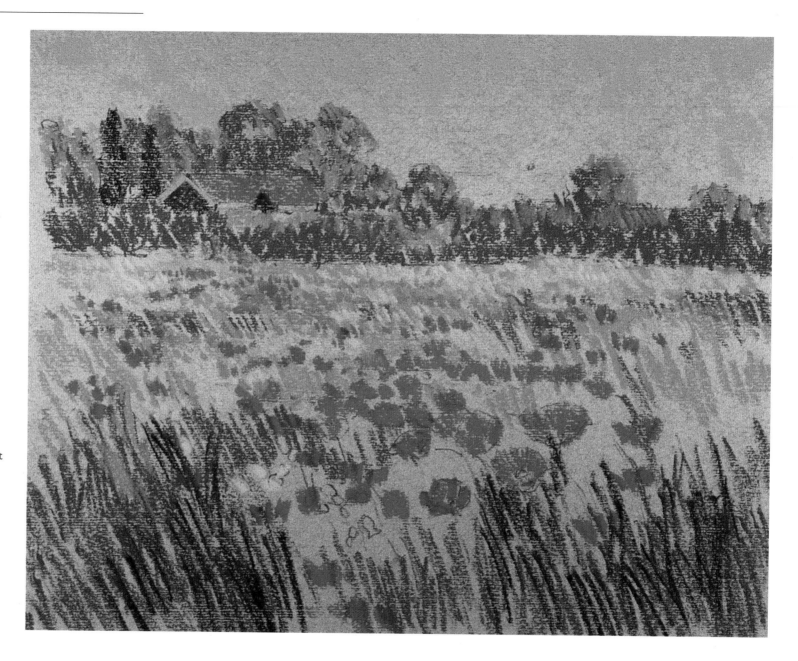

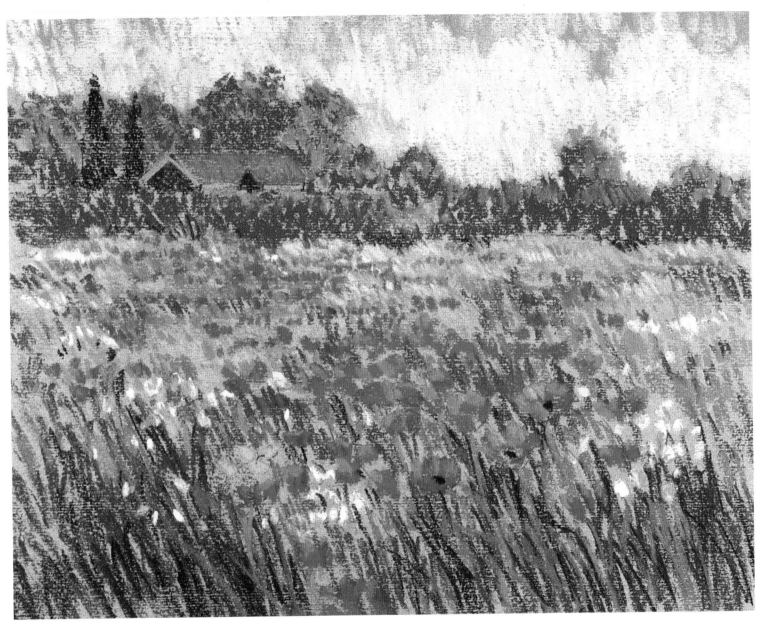

STEP 4

Use dots and dashes of white and cream together for the clouds in the sky, and allow some of your marks to overlap the blue in places. Bring tiny dots of cream down to soften the greens immediately under the hedge. Use larger dots of pale blue and white for wild flowers among the poppies, and brighten up the poppies with lighter, orangey-pink, to suggest light striking some of the petals. Bring a few strokes of this same orangey-pink down over the roof of the house. Add a few strokes of brilliant green and yellow to the foreground for a little variety.

Use long linear strokes of dark blue in the foreground, to suggest shadow and depth behind the grasses and to give a little weight to the bottom of the image. The same colour can be used for just a few poppy centres – but don't overdo it!

Water and Skies

Capturing the transitory moods and colours of water and skies is a challenge for the pastel artist. The best way to approach this lesson is to read my notes, study the illustrations, experiment with the techniques, and perhaps copy my step-by-step demonstrations. Then find a stretch of water or a view of open skies and work from life, putting your learning into practice.

PAINTING WATER

Painting water in pastels seems to be rather a contradiction in terms, because water is basically transparent and colourless, while pastels are opaque and rainbow-coloured! However, all you need to tackle water

Aims

- To find simple techniques for painting still and moving water and reflections
- To learn how to simplify what you see
- To practise painting water, skies and clouds, applying different techniques
- To learn how to integrate the sky with land and sea

successfully is practice in order to discover the techniques to use to capture what you have carefully observed. You also need patience to study the water in a scene, in order to distil and simplify what you see.

Still water will reflect the sky, and also its surroundings, and will provide you with the opportunity to link sky and land in the best of ways – by echoing colours and shapes. Moving water is a little more difficult to paint, but observation will reveal that moving water tends to repeat the same shapes, and gradually you will make sense of the apparent chaos before you. The shapes you see will depend largely on currents and eddies, and obstructions in the path of the water. With practice you will be able to paint water in a spontaneous way, rather than with the overworked finish which may result from a try-and-try-again approach.

Photographs freeze the movement of water, which can sometimes be helpful, but it can also lead to a rather stiff result. So, observe first! If you live in a town, look for a park with a pond or stream; garden centres often have water features; and if all else fails, even a large puddle will do!

Notes on painting water

Calm water
- Paint reflections before tackling any movement of water on the surface.
- Reflections will be less intense in colour and tone than the things they reflect.
- Edges of reflections may need to be softened.
- Check the proportions of reflections – they are not always the same size as the things they reflect.
- Ripples must be perfectly horizontal – rivers, lakes and ponds do not slope.
- Large areas of open water, which may look uniform in colour, are usually darker in the foreground and reflect more sky in the distance. Using one colour will look flat and solid. Use different hues, adjusting tones gradually, to avoid monotony – this will give the impression of transparent depths and slight movement.

Moving water
- Half-close your eyes to simplify the subject, and study the broken shapes of reflections carefully; they become broken up and elongated, making distinct patterns. Larger shapes will be closest to you, and shapes will diminish in size as they move away from you, as will the spaces between shapes.
- Look for the direction of moving water.
- Although it looks wonderful, be careful not to overdo white froth or the white sparkle of sun on water – too many white blobs may spoil your picture.

Use any dark colour for the bank; use a slightly lighter tone with vertical strokes for the reflections and wipe gently downwards with a tissue or finger. Paint the water's surface with horizontal strokes of a light colour.

Use broken colour for varied sky reflections. Stroke horizontal lines on for surface ripples.

Use dots of colour for stones on the river bed. Fix, and gently stroke light colours over the top for the water.

Create the rock and blend its shadow as before (top left). Suggest moving water by using the points of light-coloured pastels for circular ripples.

Paint both ripples and reflections with horizontal linear strokes.

Suggest recession by making large ripples in the foreground and smaller ones in the distance. Trap other colours inside the bigger ellipses.

Imply rocks with short side strokes of dark colour; water with linear strokes; and froth by pressing hard with a white pastel.

89

REFLECTIONS AND RIPPLES

The water in this demonstration reflects the sky, some nearby foliage and swirls around the wooden posts. This will give you the opportunity to practise water movement and reflections, but be aware that water is a complex subject, and you cannot use the same technique for every stretch of water. It is important to observe your subject carefully, and to think hard about how to represent what you see. If the water is shallow, more of the colours of the bottom will be evident, for example, unlike this demonstration where we are simply dealing with the surface of the water.

If you decide to use this image for practice purposes, notice that the ripples in the foreground have larger spaces between them than those behind the posts, and that there are fewer changes of tone in the distance, too. The slight tilt of the smaller post means that its reflection must be mirrored in the opposite direction.

STEP 1

On medium-grey pastel paper, working from the top, apply light and medium blue with vertical side strokes. Use dark brown for the posts, breaking up the colour in the lower half into small shapes to depict the reflections.

STEP 2

Add vertical strokes of darker blue, and medium turquoise for the foreground water, and blend in places with a finger. Work some yellow ochre and light turquoise onto the posts in order to lighten them and to create texture. Use horizontal strokes also of light turquoise for surface ripples.

STEP 3

Add more large horizontal ripples at the bottom with blue-green, and flick in linear strokes of olive green, blue-green and turquoise for the reeds. Use horizontal strokes of cream for sunlight on the water's surface, and a little yellow ochre and cream on the reeds for sunlit parts. Finally, put in the bird on the post – and do it quickly, without fiddling!

SKIES

I love to paint skies and clouds, and I am sure you will too. There is something magical about recreating the softness and atmosphere of a sky. At first glance it looks deceptively easy – take a blue and a white pastel, blend a bit here and there, and you have it! However, skies are much more fascinating than this. The English landscape artist, John Constable, produced countless small studies of skies, and I recommend that you do this too, perhaps keeping a small sketchbook for practice images like mine on these pages.

When painting skies, we are actually painting light and water vapour. We must be able to feel we can fly through the sky, not crash into a wall of solid colour. Pastel is perfect for this, and all the various techniques can be used. However – do make sure that the technique is in keeping with the rest of your image, or your picture will lack visual harmony.

The strongest colours and the largest cloud shapes are right over your head. At the horizon, the sky will be paler in colour as atmospheric haze takes effect, and the clouds appear smaller and closer together. Remember that large, full-bodied clouds are three-dimensional, not flat, so using light, medium and dark tones will help to describe the form. Highlights are not always on top of the clouds – look for the position of the sun.

Clouds are seldom just white or grey. Many factors influence their colours – sunshine, time of day and weather, for instance. The nuances of colour may be subtle, but they are worth observing carefully and exaggerating a little in your sketches for added impact.

Top Apply blue with side strokes, leaving a gap for the clouds. Stroke on some cream pastel and use the fingers to blend gently. Lastly, apply white edges, pressing more firmly, and again blending in with the fingers.

Bottom Apply various colours with side strokes and use tissue to blend. Press pale cream hard for highlights, and soften in places with a finger.

Left Sweep pastel across the paper with side strokes, and blend only at the bottom for fluffy clouds.

Right Build up the cloud bank with short strokes of colour. This broken-colour technique works well on textured papers where it is difficult to blend.

Left With three blue pastels, use feathering strokes for the sky. Cross-hatch the clouds, using pale pink, grey and white.

Right Tissue-blend ochre and yellow for the sky first, side stroke ochre and purple-grey on top for the clouds. Hatch lines of light purple-grey to darken the sky. Finally, press firmly with palest lemon for the sinking sun.

LINKING SKY AND LAND

The best way to integrate sky and land is to
work on both simultaneously, echoing the
colours, the shapes and the technique in
both areas. If you do this, you will not be
creating two unrelated areas, which could
be a problem.

ECHOING SHAPES

Clouds move and change, so decide
quickly on the main colour theme for the
sky, get the main large shapes down and try
to stick to them, even if the sky changes.
Then try to find and subtly emphasise
elements in the land that are similar in
shape – a winding road or a line of trees,
for instance, might echo the shape of your
clouds. Trees overlapping areas of sky will
also knit the two areas together.

ECHOING COLOUR

As we learned earlier, a stretch of water will
mirror the sky, linking sky and land, but
don't rely only on water. Certain light or
weather conditions will give opportunities to
exaggerate cloud colours to echo the
colours of the land, even using ochres, pink-
greys and soft green-greys. This may sound
odd, but I promise it will work – look at the
work of the contemporary British artists,
Edward Seago and Trevor Chamberlain.

Here colours have
been chosen to link
sky and land. In reality,
the sky would not have
been quite so ochre,
but exaggerating the
colour in the sky gives
added impact and
harmony to the scene.

Obviously the stretch
of water mirrors the
sky colours, but the
shape of the dark
cloud also echoes the
shape of the tree,
which in turn overlaps
the sky, taking the eye
up from the fore-
ground to the sky.

Above This tiny thumbnail sketch, done with a 4B pencil, was sufficient to remind me of the main cloud shapes, even though they were scudding quickly across the sky and changing before my eyes.

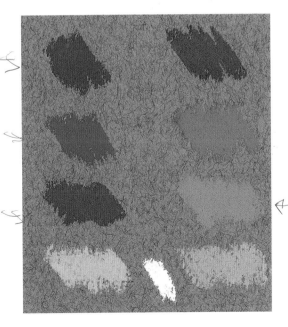

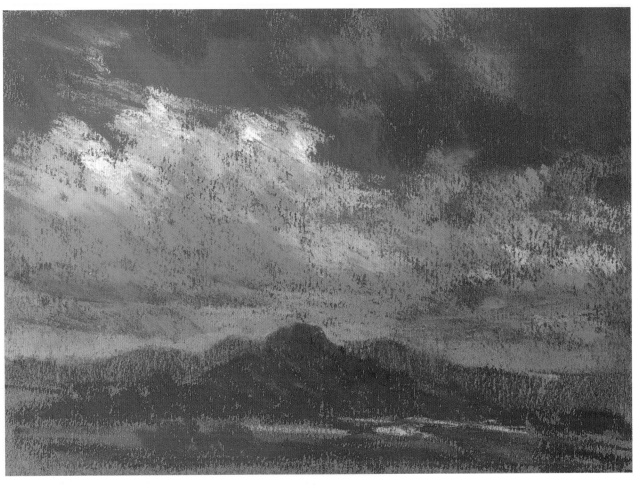

Using the thumbnail sketch and the limited palette of colours shown at left, I worked on this landscape in my studio, away from my subject, to create a more personal interpretation. The colours were mostly scumbled on, using side strokes, and occasionally blending with a finger to get rid of the texture of the paper. I pressed harder with the lightest colours but kept the edges broken and windswept. I tried to capture an impression of moving clouds by using the occasional horizontal, which also echoes the horizontal forms of the land. All the sky colours repeat in the land.

SKY AND SEA

The problems of linking sky and sea are largely solved by the reflective quality of a large body of water. However, because the sea reflects the colours in the sky, it is best to paint from life on days when the sky won't change too much as you work. If the sky changes, so will the sea and the whole character of your scene!

PAINTING THE HORIZON LINE

On most days the atmospheric haze causes sea and sky to melt together, but sometimes there is a distinct contrast between sea and sky at the horizon. If you use a hard edge between sea and sky, you will lose the sense of space in the picture.

Remember that the horizon line is really an illusion – the sea and sky don't actually stop there. The surface of the earth simply curves away, preventing us from seeing any further, and a hard edge would destroy the illusion. Paint the colours you see, but soften any hard horizon line slightly with a finger or torchon, or break across the line with a few directional strokes of pastel.

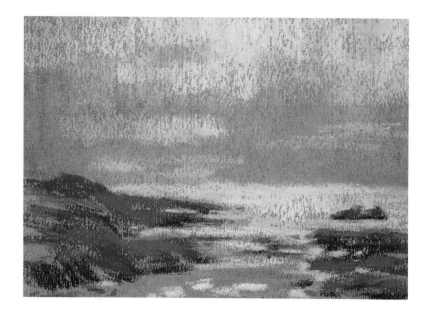

Right In the top example the horizon line is hard-edged, while in the lower example it has been slightly softened with a finger. I hope you can see that the softer horizon line looks rather more natural.

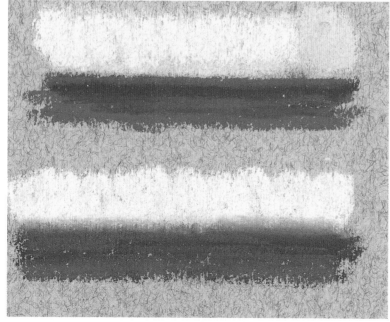

Above I chose an unusual range of colours for this scene, which gives it a special evening light atmosphere: cool and warm greys, blue-purple, medium red-grey and light pink-purple. I worked on a medium-grey paper. I used vertical side-strokes of colour for the sky, laying lighter colours gently over darker ones, pressing quite firmly for the lightest central patch of sky at the top of the picture, and then I echoed those colours in the sea and the estuary with horizontal strokes. It is a small 13 x 18cm (5 x 7in) colour sketch, but it contains enough information for a large painting of the same scene, when coupled with some photographs of the rocks in the foreground. As an interesting experiment, try copying this, keeping to the same range of tones from light to dark, but with a different range of colours.

SEASCAPE

The steps in this example show my approach to a seascape. I linked sky and land by repeating the colours in both areas, and brought the sky colours down into the land at a very early stage. I fixed the pastel between each stage, so that I could scumble colours over each other, which allows the colours underneath to show through.

In this composition, although the horizon line is central (a potentially hazardous position) the eye is not drawn to it because it is softened by atmospheric haze. Instead, the picture is divided more by the strong foreground diagonal.

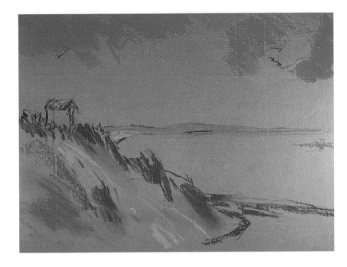

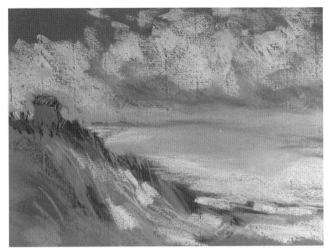

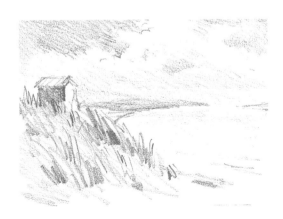

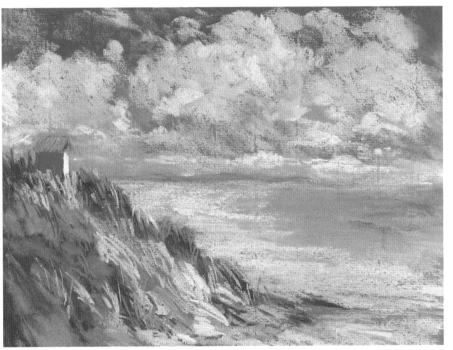

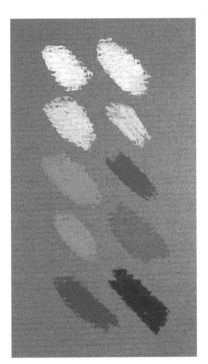

Tip

Make a study of clouds to learn the different types of cloud formation, and to increase your awareness of nuances of colour.

SUMMER CLOUDS

This demonstration gives you the chance to try the technique of blending in order to achieve airy clouds. If you feel you would like to use different colours, please do so, but remember to echo the cloud colours in the land, and also to be true to the direction of the light. In this picture, the sun is high and illuminates the tops of the clouds, so this means that the central part of the cloud will be a mid-tone and the undersides of the clouds will be the darkest in tone. Also remember that the clouds nearest to the horizon are the smallest, as they are the furthest away from you.

It is really important to vary the strength of your touch when painting clouds. If you press very lightly, you will be able to skim one colour over another, and if you press hard you will make marks which are more dense. Do not generalise too much with the edges of cloud, forming lots of perfect semicircles. Cloud edges are often wispy and ragged, broken by the wind, and if you press first hard, and then gently, and twist your wrist as you work, you will have a varied edge, which will be more realistic and true to nature.

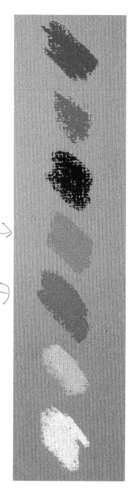

STEP 1

Apply side strokes of blue-purple, and blue lower down. Blend at the top of the picture with your fingers for solid colour, and further down blend with a tissue for a softer effect.

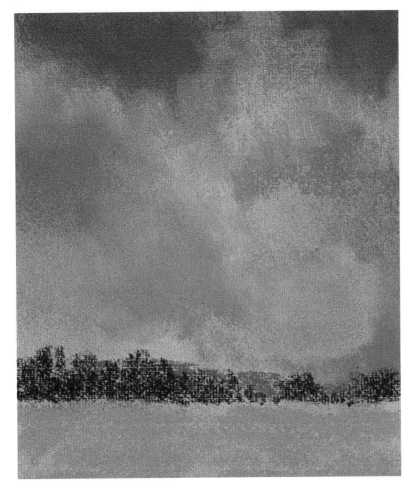

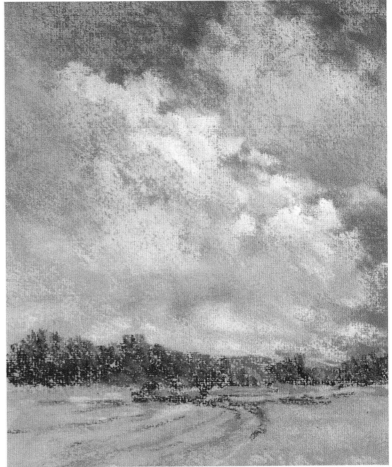

STEP 2

Use side strokes of yellow ochre and pale yellow-green for the clouds and blend with fingers (as I have done on the left). Add purple for the distant hills and short strokes of dark green for the trees. Side stroke the yellow-green gently across the field.

STEP 3

Scumble cream pastel across the sky and clouds with light side strokes, and then press more firmly with cream-white for cloud edges. Add tiny strokes of pale green to illuminate the tree tops, and use linear marks of cream, yellow ochre, dark green and purple for the details in the field. Finally, define the blue sky spaces a little more carefully.

Sketching for Painting

By now you should be feeling much more confident with your pastels, having practised techniques, and applied those techniques to a variety of subjects. You will realise by now that pastels are exceptionally versatile and that the world is your oyster in terms of subject matter. I have offered you some starting points on the long journey of becoming an accomplished pastel painter.

In this lesson, we are going to examine another more sophisticated starting point: the collecting of information for use at a later date. Some artists like to do all their work on the spot, but many others develop paintings from sketches, notes and photographs that they have collected gradually over a period of time and from

various sources. Sometimes you may not have the luxury of time to complete a pastel picture, or the confidence to add tricky subjects such as figures to your scene. This is when your sketchbook becomes an invaluable aid, and you will discover that even the quickest sketch is far better at jogging the memory than a photograph, because you will have really looked and used your powers of observation. However, a camera used to back up your sketch turns a photograph into a useful additional tool, rather than your only source of information. Even if you only have a pencil with you, you can still make written notes about colour on a tonal sketch, as a reminder for later on.

I suggest you try a series of sketches like those in this lesson, using your own choice of subject matter. Take back-up photos if you wish. Then, away from your subject, try to produce an image from your sketches. You will see quite quickly whether you have given yourself enough information to work from; if not, you will need to be a little more specific next time.

Aims

- To find out how to develop sketches for information purposes
- To learn what to look for when sketching
- To learn how to animate a scene and suggest scale by adding figures or animals
- To study basic linear perspective and make an angle gauge

These are tiny pastel pencil sketches (only 8 x 13cm/5 x 4in). Although small, they contain enough information to paint from, even without a back-up photo.

WORKING OUT OF DOORS

Any artist standing at an easel to work in the middle of a town will attract fascinated onlookers. Their comments are not always helpful, and although you can pretend to be deaf, your concentration will still be disturbed. Also, a box of jewel-coloured pastels will attract small children like a magnet, and your stocks may disappear into small pockets. This is where a sketchbook and a camera (if you like to use one) will become your best allies. You can tuck yourself away to sketch unobtrusively, and the camera will record details you may miss in your sketch.

Tip

Don't hesitate to take the opportunity to attend courses, or go on a painting holiday. You will discover that all are welcome, complete beginners painting away alongside the more experienced, all of them sharing in the fun, and the problems, of producing paintings. The important thing is that you will be able to work without constant interruptions from family and friends – and you will develop in leaps and bounds.

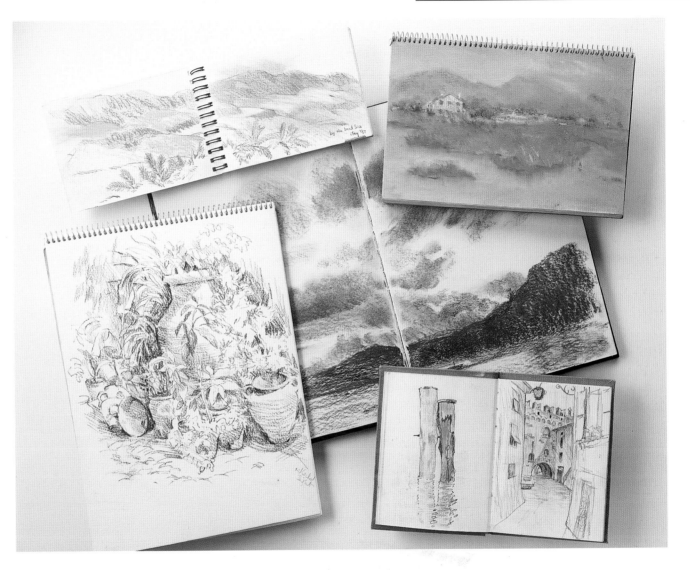

A selection of my own sketchbooks.

COLLECTING INFORMATION

You can collect information in a sketchbook using any medium – pencils, paints and crayons as well as pastels. If you have no colour, you can work in black and white, making written notes to remind you of the colours in the scene. The important thing is to do your best to record visual information with care and observation, selecting the essentials of the scene.

If you like the idea of producing coloured sketches to work from at a later date, but would rather not cart a large box of pastels around, then pastel pencils offer a conveniently portable alternative. They are also much cleaner to work with than soft pastels, which may be an advantage when sketching. All linear techniques are possible with pastel pencils – and of course you can blend them easily with your fingers.

You could also begin a sketch with a charcoal or conté pencil, or even a fibre-tip pen, and then add colour with pastel pencils. If you buy sketchbooks with tissue interleaves, this will protect the picture from smudging; otherwise you will need to fix your work (I carry a tiny can of hairspray for this purpose).

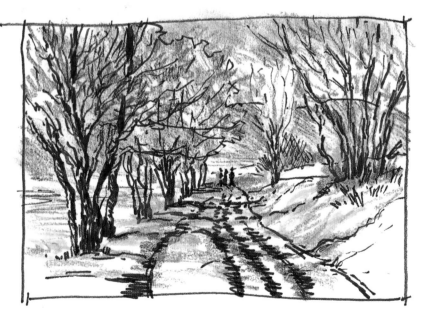

Left I began this little 8 x 13cm (3 x 5in) sketch with brown fibre-tip pen and used pastel pencils on top, blending with my fingers in places.

Right I used a blue pen initially, and pastel pencils rubbed with fingers for the colour.

RE-CREATING THE SCENE

On a visit to a friend's house in Spain I made a quick thumbnail sketch, and a 23 x 15cm (9 x 6in) colour sketch of this lovely old wooden door. I had a small tin of pastel pencils with me and a spiral-bound sketchbook of pastel paper. I used just nine pastel pencils, and the cream pastel paper worked as an additional colour, and I also took some back-up photos. On my return home, I discovered to my horror that I had lost the film, although on a previous roll I had one long-distance shot of the subject. However, because I had done a sketch, observing the doorway for a while, thinking about composition and using appropriate colours, I was able to work comfortably from my reference material to produce a pastel painting away from the subject.

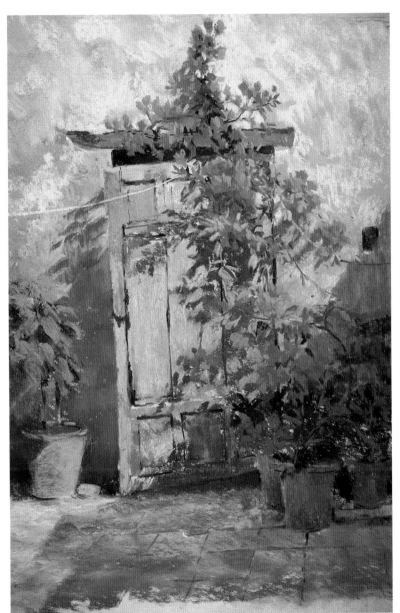

BOUGAINVILLEA AROUND THE OLD DOOR
My sketches and a distant photograph (*far left and above*) provided me with enough information to work on the finished pastel painting.

SKETCHING FIGURES

You might be able to get away with a slightly incorrect shape when drawing a distant hill, but if you decide to include figures in a picture, or attempt a street scene, distorted figures or incorrect perspective will spoil your best efforts. Mistakes are always the first things to attract attention in a painting.

Putting figures into your pictures is not easy. It is difficult to sketch figures anyway – they do not always stand or sit for long enough for you to capture them adequately. However, it is worth the effort of practising, because figures will add interest, life and scale to a scene. Pastel pencils are very useful for small practice figure sketches, and

I suggest you produce several pages of figures like mine, using either members of your family as models, or pictures from newspapers or magazines, or an articulated wooden mannikin figure (available from art shops). Take a pocket-sized sketchbook and a soft pencil with you everywhere, and make quick sketches of people whenever you can. Don't worry about details; just try to capture the main shape, and check proportions.

Think about the person's spine and draw this first – this will ensure you get the stance right. Then look for the angle of the shoulders and the hips; if the shoulders tilt, the hips will tilt in the opposite direction. There is only one way to become relaxed about drawing figures, and that is to practise.

Tip

Always make heads smaller than you think they should be.

Practise drawing figures near and far; soon you will have lots in your sketchbook to use at a later date.

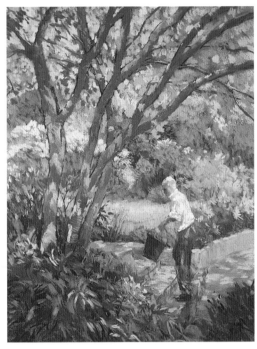

Try lots of little pastel pencil sketches like these. Join groups of figures together as one shape, adjust the colours slightly and add the heads last. Notice that I have not emphasised feet, hands or features.

Above THE GARDENER
While I was working on this picture the gardener passed by regularly, so I indicated where his head and feet would be, and did a quick separate sketch. Later, I added the figure to the picture.

PUTTING FIGURES INTO PICTURES

When you want to add a figure to a painting while you are working, but feel a little nervous about doing so, make a mark for the top and bottom of the figure in relation to the surroundings. You can then finish the figure later. To add a figure to a painting when you are away from the subject, you could try drawing the figure onto a piece of tracing paper, and then place the sheet over the picture in the

right spot, to see if the figure is in the correct scale. If it looks right, make a couple of tiny marks to indicate its position and then include the figure, making sure that you use a similar pastel technique to the rest of the picture. A human figure will instantly attract the viewer's attention, so if you want to draw the eye to a focal area, that is a good place for your figures. Look for opportunities to use counterchange: a dark figure against a light background, and vice versa.

Left An artist's articulated wooden figure is extremely useful. Use it to recreate a pose and check proportions.

105

THE BRIDLE PATH, AUTUMN

I am unfamiliar with horses – all those legs! – and I was a little nervous about including one in my picture, so I waited until this horse and rider had moved along the path and presented me with a simpler shape! They also then provided the perfect focal point for this woodland scene.

SKETCHING ANIMALS

Just as figures add life and scale to a scene, so do animals. You do not need to be an expert animal painter, but you do need to make sure that any animals you include in a scene are depicted in the correct scale to each other, and to their surroundings. Do your best to get the silhouette right, and your animal will be believable. Even if you live in town like me, and have little or no access to farmyard animals, you may well find a local park with a duckpond, or perhaps a riding stables.

Then, of course, there are domestic animals. Sketching the family pet is always a challenge – even a sleeping cat knows when you begin to sketch, and will inevitably stretch and move, but at least this will force you to be decisive and sketch quickly. Make as many animal sketches as you can – they will become a useful source of reference material.

For most of these little sketches, I used a 2B graphite pencil, and then added a little colour with pastel pencils. Go for the main silhouette first, by squinting to simplify the shape and eliminate details. Once the shape is right, you can add a few details if you wish. I could not resist the colours of the chickens and cockerel, which I sketched directly with pastel pencils.

TACKLING PERSPECTIVE PROBLEMS

If you have looked at some of the books on this subject, you may be feeling quite terrified about this aspect of painting and all those complicated diagrams. Let me reassure you by passing on some attitudes to perspective that I have encountered. I remember being told, as a student, 'Don't worry about perspective. Draw what you see, and then use perspective as a tool to check your drawing if it looks wrong.' John Ruskin, in 1856, said, 'Turner, though he was professor of perspective to the Royal Academy, drew buildings with only as much perspective as suited him.' Ruskin also recommended that students should 'Treat perspective with common civility, but pay no court to it.' How refreshing.

I have watched many students struggle with perspective, because they begin with the rules, rather than with their eyes. For now, I suggest you make note of the basic points here by copying them into the back of your sketchbook. Then, when you are in the field, draw what you see, try using some of my tips, and if necessary, use perspective rules to check what you have done if it does not look quite right.

EYE LEVEL

Finding your eye level is very important. To find it, put the spine of your sketchbook horizontally on the bridge of your nose. Look just above the top edge of the book, and everything you see at that point will be at your eye level (which is, in fact, the horizon). Notice that all the lines that travel back into your scene will meet at a vanishing point on this eye level line, and remember this important rule: all receding lines above eye level travel down towards the eye level (or horizon); and all lines below eye level travel up towards it.

The horizontal broken line is the eye level.

DRAW FREELY, BUT CHECK PROPORTIONS

Having established the eye level on your paper, draw the scene freehand. Then check proportions carefully – often a window or door in perspective is narrower than you think: check the width against the height carefully (see diagram, right). Keep your drawing light to begin with, perhaps just making marks to indicate the positions of things before drawing more firmly.

CHECK ANGLES

I give an angle gauge to every student who comes on a painting holiday with me, and – hey presto – all perspective problems are solved! It is hard to believe that a simple little device like this can save so much headache. To make your own, use two pieces of stiff card, or even thin strips of balsa wood about 15cm (6in) long. Hold the two pieces together at one end with a split pin paper fastener (the kind that looks like a tiny metal mushroom with a round head and a divided stalk), splaying out the stalk at the back of your pieces of card. Then all you need to do is hold up the gauge as if it were pressed flat against a window between you and your subject; line up one arm with a vertical, and the other with the angle. Then bring the device down onto your picture to check your drawing.

Measure to check proportions. Here the height of the door is three times its apparent width.

Angle gauge

SKY SHAPE

This is not strictly a perspective tip, but it is helpful when you are tackling a street scene or a group of buildings. Begin by looking at the shape of the sky, rather than at the shape of the individual buildings. If your sky shape is correct, you will be able to develop the buildings from the silhouette which has resulted from it.

Right Explore the underlying perspective of my painting of a doorway in Greece by placing a large piece of tracing paper, the size of the page, over this street scene. Continue the lines from the top and the bottom of the door to where they converge. This will be the vanishing point, which is on the eye level. Your vanishing point should be outside the edge of the rectangle.

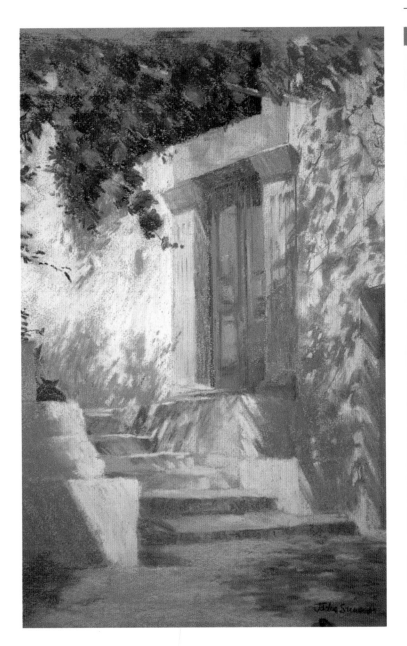

Tip

If you produce a smashing sketch and want to produce a painting from it, you must ensure that your proportions remain the same. An accurate way of doing this is to 'square up' the picture by drawing a grid of squares over your sketch, then draw a larger grid to the same proportions on your pastel paper, and reproduce the drawing square by square. However, this can lead to a very stiff result, and I prefer to ensure that my pastel paper is in exactly the right proportion to my sketch, and then to draw freely.

Here is the easiest way to make sure the proportions are the same. Put your sketch on the corner of your pastel paper, and place a ruler from corner to corner. Extend the line and it will extend the rectangle exactly in proportion to the sketch. If you leave a small margin around your picture, you will find this useful for testing colours.

Winter Painting

A determined landscape painter will work out of doors at any time of year, and of course the seasons make little difference to a still life painter. Winter may, however, bring snow, altering the landscape dramatically, and the painting of snow presents fascinating problems to solve. Winter will also bring numbing cold, and wet days when you are forced to work indoors, and since still life may not always appeal to you, I am going to offer you other options in this lesson.

USING PHOTOGRAPHS CREATIVELY

You may feel that using photographs is either lazy or cheating, yet great artists such as Degas, Corot, Delacroix, Manet and Sickert all used photographs as a source of

reference. They did not, however, copy photographs slavishly. They first learned to be painters, able to work from life. The photograph then became for them simply another tool to be used with imagination and creativity.

Copying photographs without developing your knowledge from life will result in work that suffers from poor observation, unskilful drawing and unimaginative colour. So how can photos be used creatively? I have listed some ideas on this page, and you may like to try them out. Always use photos you have taken yourself, because you will have composed the scene through the viewfinder of the camera.

Using photographs in this way will help you to improve your compositional skills and to make decisions about colour and tone based on what the picture needs, rather than what the scene dictates, which can be really exciting, and so much more fun than just copying. You will be developing a new creative muscle!

Aims

- To consider various options for indoor painting
- To see how to use photographs creatively
- To learn what to look for when painting snow

Creative Uses of Photography

- Make an enlarged photocopy of a photograph in black and white, then paint from the photocopy using your own colour scheme based on either colour harmony (see page 50) or complementary colours (see page 48).

- Combine several photographs, using elements from each to create a new scene. A sky from one photo, for instance, could be combined with a landscape from another, and figures added from a third photograph. Make sure the light source is consistent. If you photocopy each photograph, you could cut out the elements you want to combine and stick them together.

- Crop the edges of a photograph to change the shape completely.

- Make an enlarged photocopy of a photograph, trace it and then use the image in reverse.

- Change the weather or time of day to create a totally different mood, taking care to adjust the tones carefully.

- Make a simple freehand tonal sketch from your photograph, selecting and simplifying as you work. Emphasise some elements and eliminate others in order to improve the composition, for instance, or the tonal balance. Paint from your sketch.

- Eliminate all three-dimensional form and create a picture made up of flat, coloured shapes. The finished result may look rather like a mosaic.

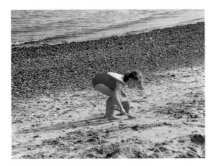

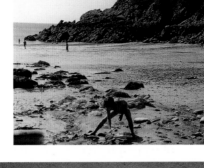

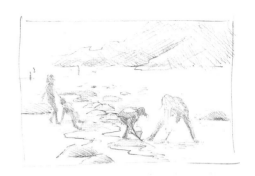

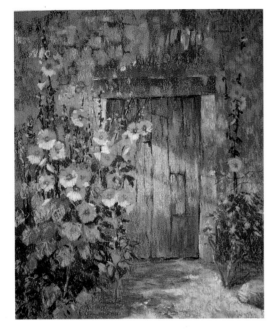

BEACH SCENE

Neither of the poorly composed photos *(above)* would have made a painting, but I liked the figures, so I put them together in a thumbnail sketch *(top right)*. I had to be very careful about the direction of the light; in one photograph, the low sun casts long shadows to the left; in the other the shadows are shorter. I adjusted the shadows in my picture so that the light came from a single direction.

HOLLYHOCKS

I eliminated the ugly tyres from the photo, and enhanced the colours, particularly the shadows. I also simplified the leaves and the textures of the stone and wood.

PAINTING SNOW

As much as I love to paint snow and look forward to the winter months so that I can add to my store of sketches, I have to admit that I do not enjoy painting outside in it. I believe that Monet once gave himself seven minutes to complete an outdoor painting, but I am a lesser mortal – my fingers would freeze into total immobility long before I had finished. I prefer to work from the window of a car or a house, or from quick sketches done outside. I go for long walks in the snow, observing as I walk, asking myself questions such as: 'Is the sky darker than the ground; how much darker; what colour is it? What colour are the highlights and shadows in snow when the sun shines?' Photographs of snow are often disappointingly bleached and colourless, even on sunny days, so it is really important to observe carefully, so adding to your understanding and experience.

COLOUR IN THE SNOW

Snow is white. However, a quick glance at the paintings of the Impressionists will prove that snow scenes can vibrate with glorious, luminous colour. On sunny days the snow will reflect the warm colour of the sunlight,

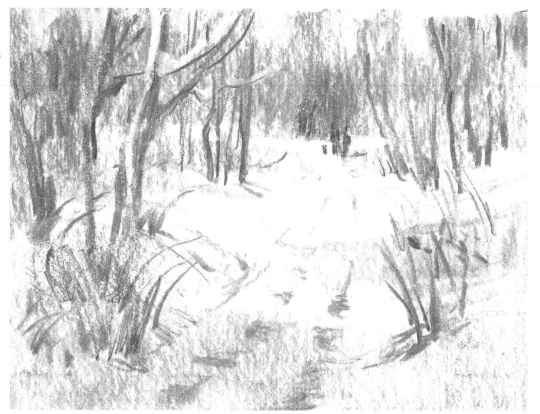

and colour from the sky. Shadows will become complementary blues, or blue-violets. In the evenings, highlights may turn a soft pink-gold. Overcast days will bring a complete change of colour – a more monochrome landscape under a leaden sky, requiring strong tonal contrasts, rather than colour, for impact. Don't worry if you cannot

see colours in the snow – it does take a while to begin to develop the ability to 'see' colours which are not immediately obvious. Take a piece of white paper with you on a walk, and hold it up to compare – you will soon see that snow isn't always just 'white'.

This is the charcoal thumbnail sketch that I used for the simple snow scene on the following pages.

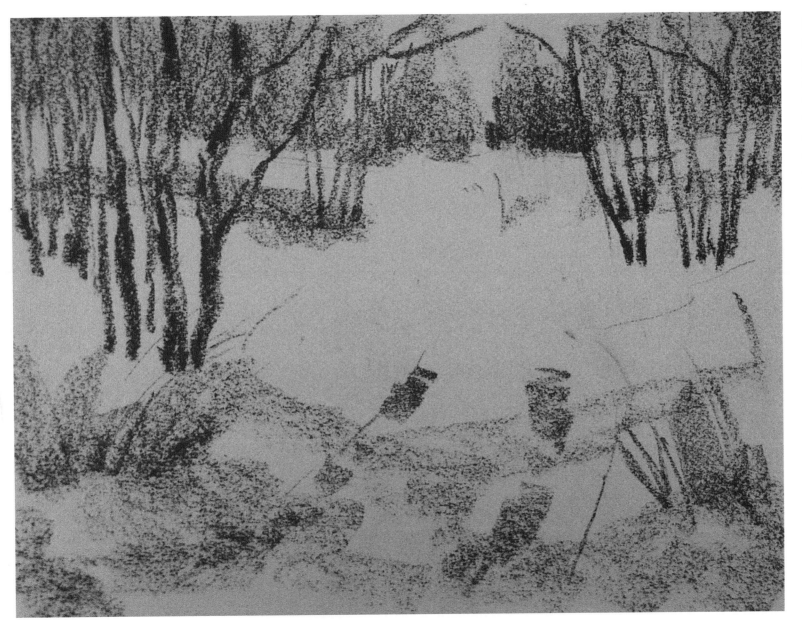

STEP 1

Using a dark grey pastel on its side, block in the distant woods very lightly with vertical marks and sweep the pastel across the foreground with horizontal marks. Then switch to the edge of the pastel and draw in trees, using heavier strokes for those in the foreground, and tiny light strokes for the more distant trees and branches.

STEP 2

Beginning with the darker of the two medium tones of blue, work over the top of the dark grey to suggest shadows in the snow. Imagine the contours of the peaks and hollows in the snow, and use marks that will follow those contours. Then use the lighter blue to make linear marks to define the sloping banks of snow, and the snow collecting on branches. Make some thin lines in the distance for lighter, snow-laden trees.

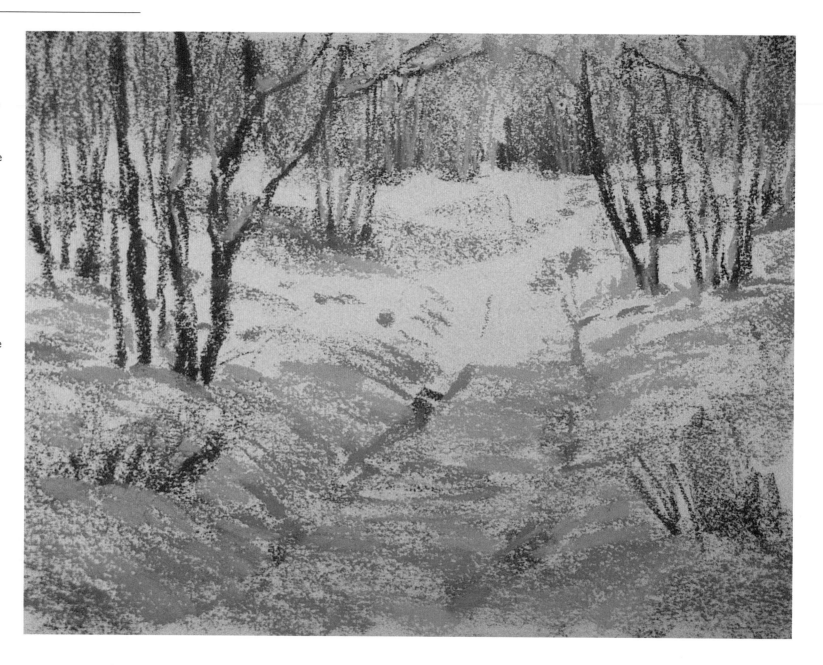

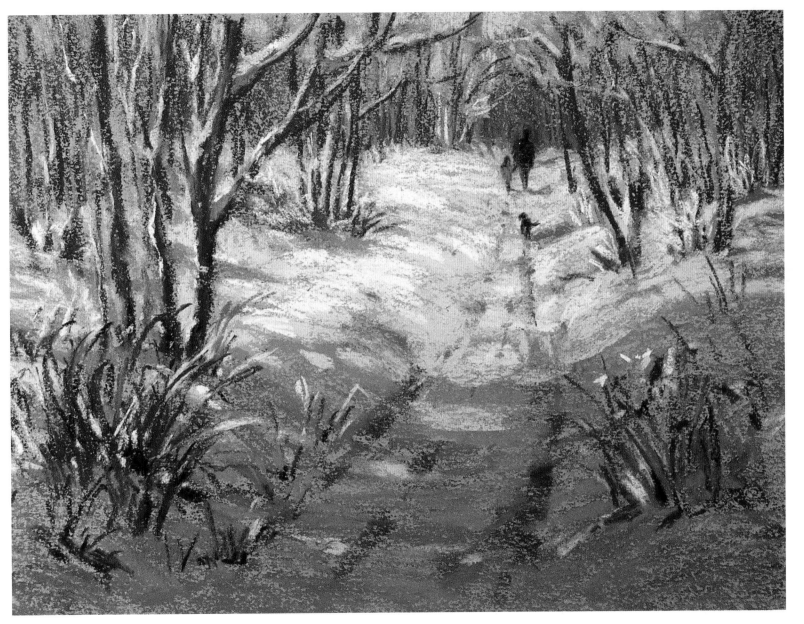

STEP 3

Stroke cream, and a little white pastel over the sunlit areas of snow. Use the cream to hint at sky behind the trees. Use the point of the pastel to pick out the snow on branches. Flick in linear strokes of dark grey, dark blue and rust for the grasses, allowing the marks to curve into the picture. Keep your strokes loose and lively – in keeping with the looseness of treatment elsewhere in the picture. Finally work across the picture, strengthening tree trunks here and there, adding touches of light, and use just a few strokes of colour for the little figures. Don't forget the shadows on the ground under the figures – they are important.

PAINTING INTERIORS

Another option for winter painting is an interior scene – anything from a small corner of a domestic room, to a more complex scene in a café or a stately home. In a sense, an interior combines landscape with still life or figure painting: we see the objects of a still life, or a figure, within the 'landscape' space of a room.

When painting a room and its contents, there are many perspective problems to contend with – not just walls but also pieces of furniture, all, possibly, with different vanishing points. I recommend that you begin with a small corner, and gradually take on more complicated subjects once you feel totally confident about perspective.

In my demonstration painting, there is one simple light source – the window – and I suggest you try a similar scene. Squint hard at it to see where you can 'lose' the hard edges of objects so that they melt into their surroundings – this is one of the keys to painting a successful interior.

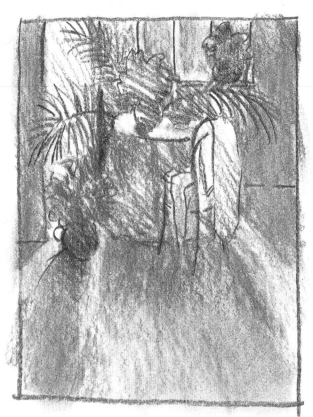

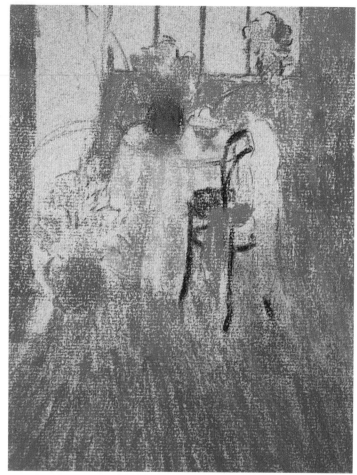

Step 1

Using your two darkest tones of blue, block in all the shadow areas with side strokes, varying the colour as you work. Use dark brown for the chair, and mix a little brown with blue for the vase on the table. Stroke some blue over the brown to soften the impact of the warm dark brown. Spray with fixative.

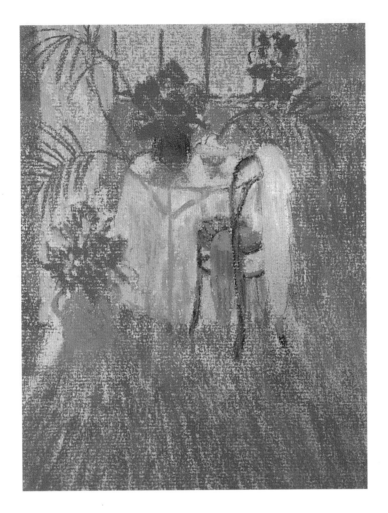

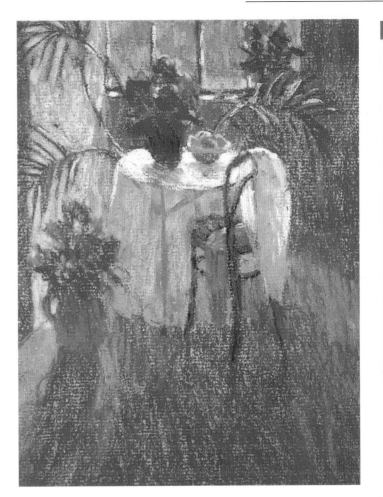

Crisp, hard edges will attract attention in a picture, and so can be useful if you want to emphasise an object or shape. However, too many crisp edges may give a rather stiff, wooden effect. By softening, or losing, edges (allowing one shape to melt visually into another without a hard line between them), you will subtly knit areas together.

STEP 2

Using medium tones of blue, add in the fall of the tablecloth, the fabric on the chair, and pressing lightly, the wall on the left and colour beyond the windows. Use stabbing marks and linear strokes for the plants and flowers. Indicate the half-seen table legs with a medium blue-grey, to suggest light shining through the tablecloth.

STEP 3

Finally, use your lightest pastels for all the light-struck parts – press hard for the tabletop, and pick out tiny highlights along the window frames, on the fruits, cloths and chairback. Use broken colour with pale blue and green beyond the windows in tiny strokes. Adjust tones gradually all over the image to convey the soft light from the window.

Experimenting with Surfaces

This final lesson gives you an opportunity to spread your wings a little and try out different surfaces and backgrounds for your pictures. As I said at the beginning of the book, you can use pastels on almost any surface, but pastel paper is the best thing to start with. You may have discovered that even pastel papers vary – some, for instance, have quite a definite texture on either side which can sometimes be quite pronounced and mechanical. I always work on the smoother side of pastel paper. My personal favourites are Canson Mi-Teinte and Fabriano Tiziano, but I also enjoy working on sandpaper, on pastel board and on surfaces I have prepared myself.

Only trial and error (or, hopefully, trial and success) will tell you which papers and surfaces suit you. There is no need to copy my examples – just study them and try ideas of your own. You should have the confidence to do this by now.

SANDPAPER

A good art shop should stock fine 00 grade sandpaper. The grittiness of sandpaper will consume your pastels (and your fingernails), but it will allow for a build-up of many layers of pastel, rather more than could be achieved on ordinary paper. Eventually, of course, you would fill even the rough tooth of sandpaper, but you can then either scrape off excess pastel pigment carefully with a safety razor blade (see page 26), or use fixative. The pastel strokes will be thick and creamy, and the finished result often looks more like an oil painting than a pastel painting. Blending of colours is possible once initial layers have been applied. If you like the idea of applying your pastels in thick, generous strokes, you may enjoy using this paper, which, incidentally, I have only found in two colours: silver grey and sand.

The pastel marks build up to a dense surface, but they still allow for fine detail.

Left Tiny dots and dashes of pastel make up the corner of a garden. The warm colour of the paper shows in places, and where the pastel is applied in several layers, the colour is rich and varied.

Aims

- To experiment with different surfaces
- To discover the merits of working on a painted background
- To learn how to prepare your own textured board
- To try working on a textured ground

EXPERIMENTING WITH SURFACES

PASTEL BOARD

Pastel board has an even, slightly gritty
surface, made by blasting tiny particles of
cork onto board. The marks you make on
pastel board have a soft-edged quality, as if
they are slightly out of focus, but once a
mark is made, it is quite difficult to shift
or blend it, as you can on paper.
Therefore, a more direct approach is
required, building up colour with
individual strokes and by layering, rather
than blending.

Pastel board holds pastel so well that
there is no need for fixative (which will
leave little spot marks if you do use it).
Pastel board is ideal for the travelling
painter because it is sturdier than paper
and so less liable to tear. You can safely
leave your fixative at home, which is just
as well, since airlines often confiscate
aerosol cans! Cut a large sheet into four
pieces for small landscape studies like the
one here that I painted in Greece.

Blue shadows on white walls are
marvellous to paint – if you have a similar
holiday photo, try a picture like mine.
Look out for reflected light, like that on
the steps in my picture, which lightens the
shadows a little.

This practice piece
shows the soft quality
of the marks, and also
how you can overlay
one colour with
another, the technique
I used most in the
painting on this page.

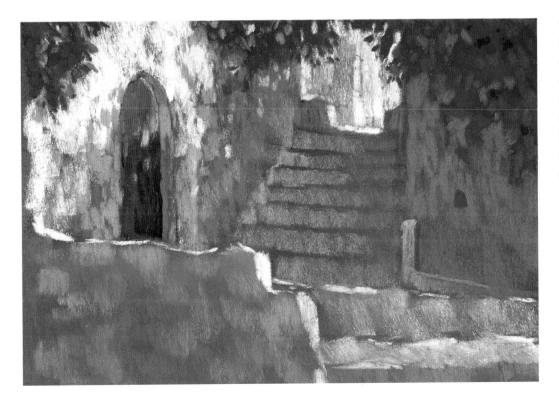

Working on warm grey
board, I built up the
colour with short
stabbing marks for the
foliage. On the walls I
used side strokes and
broken colour for the
shadows, starting with
a darkish blue, and
overlaying with
medium tones of blue
and turquoise. Finally, I
used pale cream for
the sunlit areas.

119

Tip

If you want to work on a large scale, lighter weights of watercolour paper should be stretched before applying watercolour washes, otherwise the paper will buckle. (Soak the paper for five minutes and tape it to a wooden board with gummed brown paper strip and leave to dry naturally.) Alternatively, use a heavy-weight paper.

Don't soak pastel paper for stretching – it is flimsier than watercolour paper. Simply wet it gently on both sides with a damp sponge and immediately tape it to your board. Leave it to dry naturally.

PAINTED BACKGROUNDS

The advantage of applying your own background colour is that you are not tied to the uniform colour of a sheet of pastel paper. Watercolour and gouache are both suitable for this. Apply them with a large soft brush, or put paint, thinly diluted, into a plastic spray bottle and spray colour onto your paper.

You can apply paint to any type of paper, but thinner ones, particularly pastel paper, may need to be stretched (see tip). Watercolour paper is quite different from pastel paper, and it is fun to work on a surface with a different feel. There are three different types of watercolour paper – hot pressed (smooth), 'not' (medium), and rough. The latter may break up the pastel marks too much, but the 'not' surface is fine.

WATERCOLOUR

Watercolour will allow the white of the paper to shine through the transparent layers of paint. It can be used under your pastels to give you a tinted, single or multi-coloured background, or to block in the main elements of your picture. If you do not have any watercolour paints you can use diluted Chinese ink, or even cold tea to stain your paper!

To create a flowing watercolour background like this, wet the paper and drop puddles of watercolour paint onto the wet surface. Rock the paper gently and the colours will blend together beautifully. Leave it to dry flat.

The texture of the paper breaks up the pastel marks and allows the underpainting to show through in places, particularly in the background under loose strokes of purple. This produces a lovely colour harmony because the pastel colours echo those of the paint.

GOUACHE

Gouache is another form of watercolour paint, but because it contains a certain amount of chalk it is opaque, and the chalk in the paint adds a little tooth to the paper when it is dry. When mixed without too much water, it will provide a base of solid colour. This means that if you want to create a dark underpainting, gouache is more suitable than watercolour, as you can cover the white paper completely. Try gouache on smooth, hot-pressed paper as well as 'not' surface watercolour paper, to see the different finished effects. You could also try a gouache underpainting on pastel paper – but you may need to stretch this type of paper to prevent buckling.

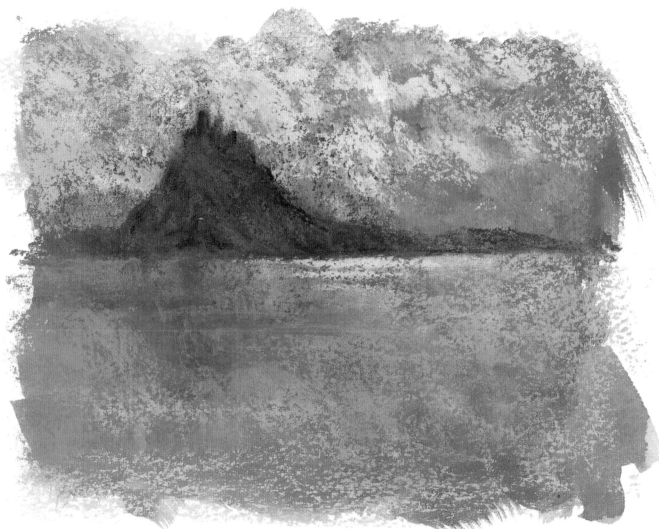

Left Brush various gouache colours onto watercolour paper (I used hot-pressed smooth paper here). Leave it to dry before using it for a pastel picture.

Above Pink, white, pale blue, pale green and light purple are scumbled gently onto the gouache background, allowing the gouache colours to show through and play a part. The castle is left as a large dark shape, although some dark purple-grey is just stroked on so as to suggest the form of the land.

CREATING YOUR OWN TEXTURED BOARD

There are various ways to create your own textured surface. You can use acrylic gesso on its own for a finish with a very fine tooth, or alternatively you could mix acrylic gesso with a little marble dust (which is like talcum powder and can be bought from good art shops) to the consistency of thin cream, for slightly more texture. However, since marble dust is not always easy to find, a suitable alternative is a ready-made substance called texture paste, available from art shops. I use Daler Rowney's texture paste, which is just the right texture; others I have tried have been too gritty.

The paste is white, but you can mix it with some acrylic colour if you want a coloured surface. It can be thinned with water, so you can control the amount of texture you apply to the board. I either stretch a piece of watercolour paper and apply the paste to that, or else I use the smooth side of a piece of mount-board. I find two coats of paste adequate, applied smoothly with an inexpensive decorator's brush. Some artists use more layers, and some rub down the surface with sandpaper to make it more velvety.

Many professional artists prepare their

For this example, I applied texture paste to smooth watercolour paper. The grittiness of the paste breaks up the pastel slightly, but fine details are still possible, as you can see. Blending lightly applied orange pastel with a finger tints the paper.

I painted texture paste onto a dark grey mount-board to show the effect. I tinted one side of the board with watercolour, and applied pastel in an experimental fashion.

Tip

When preparing a textured board it is a good idea to coat both sides; if you do not, it is likely to curl as it dries. If you forget, then put your board under several heavy books for a few days to flatten it.

own boards in this way, particularly if they work at a large size. I suggest you make a selection of textured boards or papers. Write in the corner how many layers of paste or gesso you used in order to remind yourself which you prefer. Experiment freely to begin with, and then try painting your own image.

CHEDDAR GORGE

I worked from a small thumbnail sketch that I had done some time ago. I decided to use complementary colours: warm red-grey, pinks and olive greens. I painted a piece of white mount-board with two coats of texture paste, allowing it to dry between coats. The textured surface helped to represent the crumbly rock face in the scene. Try to find a similar subject for an experimental picture like this.

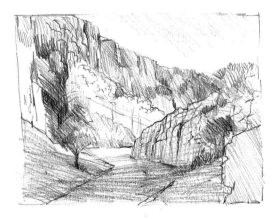

STEP 1
Having selected predominantly warm colours for the image, I decided to tint the board with watercolour, using cool blues and greens, knowing that these colours would show through in places, thus adding an interesting touch of contrast. Once it had dried, I sketched in the main elements of the composition with charcoal.

STEP 2

I blocked in the sky with warm cream and pale blue, layering the blue over the cream. I side stroked red-grey onto the shadow areas of the rock face, and began to suggest the foliage with short, stabbing marks.

I added touches of purple to the rocks on the right. I built up the greens more carefully, using the darkest colour for the shadows, and added a lighter orangey-pink to the rocks on the left. This is a rich, warm colour, which I hoped would add even more warmth to the sunlit areas; I planned to overpaint it with cream, leaving tiny touches of the bright pink showing.

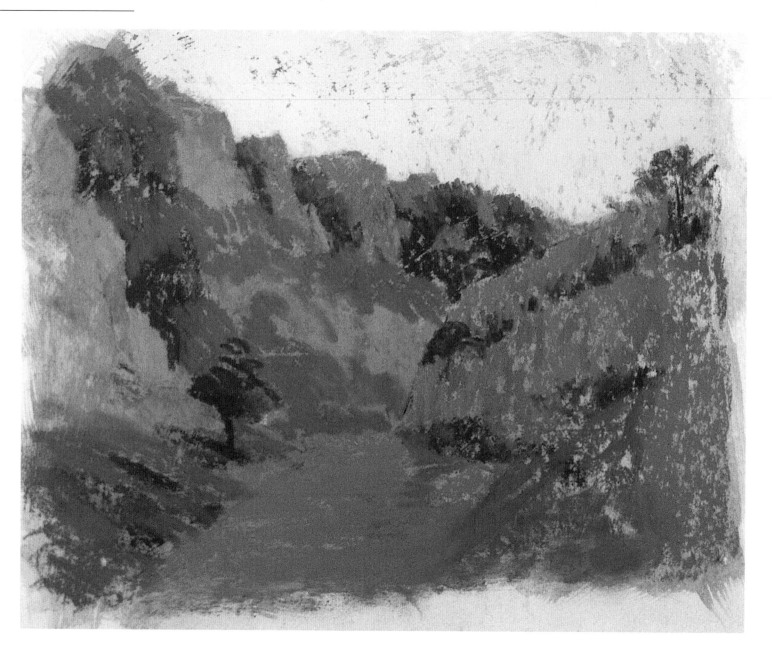

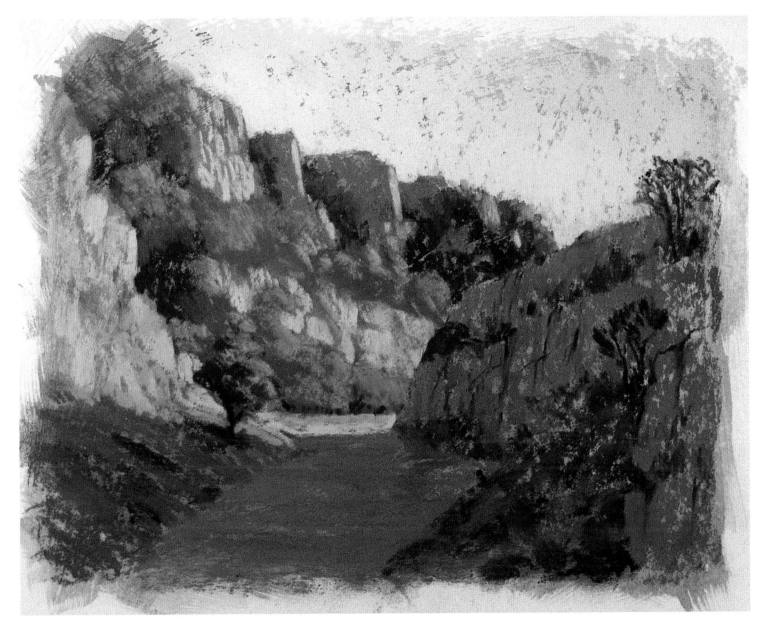

I sprayed lightly with fixative, and then, using the warm cream and lightest green, I highlighted the sunlit areas, using short strokes which allowed the colours below to show in places. I used horizontal lines of purple on the road, defined the trees a little more, and suggested cracks in the rocks with charcoal, softened with my finger in places. If you look hard, you will see where the blue-green underpainting shows through the pastel, giving the impression of texture and providing welcome touches of cool colour.

Final Thoughts

I hope that you have enjoyed reading this book and working through the exercises. If you have been diligent in your efforts, you should be feeling very pleased with yourself. You have taken the first steps on your own 'yellow brick road' (or perhaps it's green, or blue, or pink). Learning to paint is a wonderfully adventurous journey – and I truly hope you enjoy all the sights and experiences along the way.

Don't forget to add to your learning experience of pastels by visiting art galleries and museums to see original paintings, and regularly examine reproductions of the works of pastel painters in books. Look hard at the pastels of Degas, Toulouse Lautrec, Berthe Morisot and Mary Cassatt – you will learn a great deal by studying their beautiful paintings.

STORING AND FRAMING

It is always a good idea to keep your work, even pictures you don't want to frame. If you do, you will have a record of your progress, and you will be amazed to see how much you have improved if you look at work you did a year previously and compare it with more recent work.

It is not difficult to store pastels – you simply need to keep them flat and dry. If you have space for a plan chest, that is the best option; if not, simply use a large folder, and store it under the bed! Some artists protect their pastels with sheets of tissue or greaseproof paper, but this really is not necessary if the pictures are not moved around.

If you produce a painting you are proud of, do frame it. Always use a well cut mount, or even two, between the picture and the glass, and use a good quality, sturdy frame. A mount will distance the pastel from the glass, and will also act as a visual 'quiet area' between the picture and the frame, which can be important, particularly if the picture is hung on a patterned wall. The colour of the mount is a matter of personal choice – I prefer a colour that is light and neutral, which complements the picture. I often use an inner mount – called a cuff – that picks up one of the colours in the image.

The way to spoil all your hard work is to put your lovely picture in a flimsy frame and a badly cut mount. If you choose wisely and well, your picture will be greatly enhanced by its framing. I always enjoy taking delivery of pictures from my framer and it never ceases to surprise me to see how different, and special, they look when well framed.

GLOSSARY

angle gauge a device for measuring the angles to be found in a scene.

blending smoothing the edges of adjacent colours so that they merge imperceptibly.

broken colour areas of pastel created by short strokes of different colours.

chisel edge the point, or edge, of a pastel stick.

colour wheel a diagram of colours arranged in a particular way.

complementaries pairs of colours opposite each other on the colour wheel.

composition the arrangement of the various elements of a picture.

conté a dense form of chalk, used for drawings and sketches.

counterchange a dark area or object seen against a light area or object, and vice versa.

cross-hatching parallel lines that criss-cross each other at angles.

echoing colours repeated colours in a picture.

ellipse an oval.

eye-level the horizon, which is always level with the artist's eyes.

feathering vertical lines placed side by side.

fixative usually a mixture of shellac and alcohol, used to spray onto drawings and pastel pictures to prevent smudging.

focal point the main point of interest in a picture.

form the three-dimensional aspect of an object.

frottage rubbing pastel onto paper placed over a textured surface.

gesso a waterproof substance used as a primer for board, canvas or paper.

gouache a chalky, opaque form of watercolour paint.

gradations gradual changes of tone within one colour.

harmonious colours a range of colours found alongside each other on the colour wheel.

hue the name of a colour (blue, yellow, etc).

laid lines embossed lines in some kinds of pastel paper.

limited palette a small range of colours chosen for an image.

local colour the actual colour of an object (eg green grass, yellow buttercups).

monochrome various shades of one colour only.

mount card cut to surround a painting.

overlaying a method of stroking one colour over another.

palette in pastel painting, this refers to the artist's colour choices for an image.

primary colours pure red, yellow and blue.

putty rubber a slightly tacky, soft rubber which can be kneaded to shape.

recession the illusion of distance.

sanguine a red-brown form of conté.

scumbling the technique of dragging one colour over another so that the underneath colour shows through.

secondary colour orange, green and purple.

side strokes the use of the side of the pastel stick to create a wide stroke.

thumbnail sketch a small drawing made to investigate a possible composition.

tone variously used to describe both shading in pencil, and also the relative lightness or darkness of any given colour.

tooth (of paper) the textured surface.

torchon a tightly rolled, pencil-shaped stick of paper used for blending areas of pastel.

vanishing point a point at which parallel lines converge on the eye level.

viewfinder a small viewing 'window' cut into a piece of card.

vignette a scene, or group of objects, without the defining edges of a rectangle.

wash a thin layer of colour, usually paint, applied broadly.

INDEX